IMAGES
of America

HANCOCK

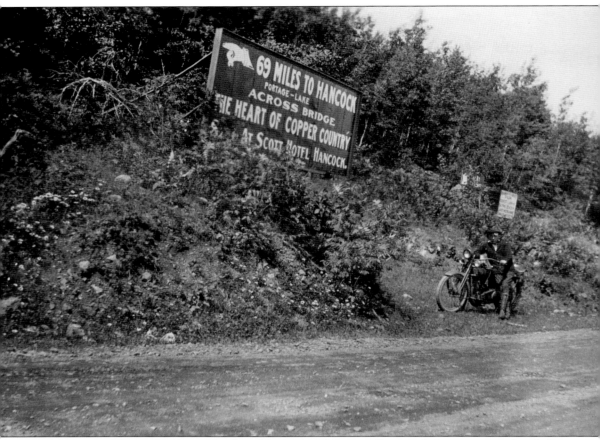

Advertising Hancock's Scott Hotel in "the heart of Copper Country," this sign was placed 69 miles southeast of Hancock near Champion, Michigan. (Courtesy of Mary Pekkala.)

ON THE COVER: This view, copyrighted by the Detroit Publishing Company in 1906, looks west down Quincy Street from Reservation Street. The intersection is anchored by First National Bank (right) and Superior Savings Bank (back cover). Quincy Street is Hancock's main artery. The streetcar tracks shown here are now buried, but most of the buildings seen in the first block still stand. (Courtesy of the Library of Congress, LC-DIG-det-4a13087.)

IMAGES
of America

HANCOCK

John S. Haeussler
Foreword by Charles Eshbach

ARCADIA
PUBLISHING

Published by Arcadia Publishing
Charleston, South Carolina

Printed in the United States of America

Library of Congress Control Number: 2014934338

For all general information, please contact Arcadia Publishing:
Telephone 843-853-2070
Fax 843-853-0044
E-mail sales@arcadiapublishing.com
For customer service and orders:
Toll-Free 1-888-313-2665

Visit us on the Internet at www.arcadiapublishing.com

To Glenn Anderson and Tim Seppanen, for
their encouragement and enthusiasm

Contents

FOREWORD

When you look at the history of the City of Hancock from its beginning in 1859, you see very quickly an abundance of forward-thinking people. Samuel W. Hill recognized the need for a village to support the growth he predicted as the Quincy Mining Company agent. His progressive plan to open Portage Lake to shipping by dredging the Portage River further insured the future prosperity of Hancock.

Sam Hill was just the start of progressives who went on to become the pioneers of the Industrial Revolution. Native copper was one of the key resources fueling the very beginning of the Industrial Revolution, and Hancock became the center of copper mining and the home of the first copper barons. From 1840 to 1880, the Keweenaw region produced three quarters of the nation's copper.

This book is a collection of vintage images and meticulously researched facts that document and define Hancock. The transformation from a profane, rough-and-tumble boomtown of thousands of recent immigrants to a refined, prosperous family town with a streetcar system, Lutheran seminary, and regional hospital is a poignant chronicle of the spirited people that established this special place—a place where fortunes are made and dreams are fulfilled. It is an environment that produced world-famous artists, photographers, industrialists, and inventors.

Through these more than 200 images, the author has produced a tiny time capsule, which preserves and celebrates the spirit of the people through hardship and prosperity. This is clearly illustrated when you see the quick recovery after the devastating fire of 1869. This spirit to persevere through harsh winters in a pristine natural environment and thrive is still a defining attribute of Hancock residents.

—Charles Eshbach

ACKNOWLEDGMENTS

I moved to Hancock in 2007 and was elected to the city council in 2010, which enabled me to chair the city's sesquicentennial celebration in 2013. The celebration included the publication of a book, *Hidden Gems and Towering Tales: A Hancock, Michigan Anthology*, which I coedited with the able guidance of Laura Mahon. My knowledge of Hancock history was greatly enhanced during the development of that book by the members of the sesquicentennial committee, to whom I am forever grateful: Glenn Anderson, Roland Burgan, Jack Eberhard, Charlie Eshbach, Robert Grame, Mary Pekkala, and Rob Roy.

This book would not be possible without the image sources, which are identified following each caption. Generous assistance was provided at Finlandia University's Finnish American Heritage Center and Historical Archive by Joanna Chopp, Jim Kurtti, Mary Pekkala, and Harri Ahlgren; at the Houghton County Historical Society Perl Merrill Research Center by Gloria Walli, Mary Lee Abata, Carol Griffin, and Pam Hawley; at the Michigan Technological University Archives and Copper Country Historical Collections by Julie Blair, Beth Russell, Sawyer Newman, Rachael Bussert, Airen Campbell-Olszewski, Abby Dillon, Zach Evans, Lindsay Hiltunen, Jeff Kabel, Dan Michelson, Brendan Pelto, and Allyse Staehler; and at the National Park Service, Keweenaw National Historical Park by Jeremiah Mason. Vicky Vichich repeatedly shared her knowledge and research materials, as well as treasures passed down by her father, Joseph Meinardi.

Many images were scanned for publication by Mike Edwards of Red Jacket Media. Gerry Perreault was instrumental in transporting archival images to and from Mike.

Glenn Anderson, Roland Burgan, Joanna Chopp, Jack Eberhard, Charlie Eshbach, Megan Haeussler, Karen Haischer, Jim Kurtti, Jeremiah Mason, Mary Pekkala, Rob Roy, Bill Schoos, Tim Seppanen, and Ron Studer contributed significantly in identifying images and/or proofing text.

Acclaimed photojournalist Charlie Eshbach graciously agreed to write a foreword, and his advice was invaluable to this novice writer.

Jacel Egan was my first contact at Arcadia Publishing, and Maggie Bullwinkel was my go-to resource at every step of the book development process. Their experience, patience, and understanding are greatly appreciated. Arcadia's editing staff, notably Jared Booth, deftly smoothed the rough edges throughout the book.

I am also thankful to the following for their assistance on this project: Mary Lou Anderson, Blast From the Past (Al McClellan), Church of the Resurrection (Jen Norkol), City of Hancock (Glenn Anderson, Karen Haischer, Beth Fredianelli, Tina Posega, Ted Belej, Barry Givens, Kevin Hodur, Bill Laitila, Lisa McKenzie, Jeremie Moore, and John Slivon), City of Houghton (Scott MacInnes), Mark Dennis, Diocese of Marquette (Fr. Jeff Johnson), Dave Doll, Dave Dow, Corbin Eddy, Diane Eshbach, Carol Freeman, Rick Freeman, Joshua Frost, Toby Frost, Deb Gardner, Mike Gemignani, Helen Haeussler, Jack Haeussler, Maggie Haeussler, Hancock Public School District (Monica Healy, Jill Karkkainen, Lisa Meyer, Sue Zubiena, and Molly Simula), Kevin Hodur, Charlie Hopper, Houghton County Historical Society (Kristy Walden, Herb Leopold, Gerry Perreault, John Berry, Brian Keeney, Bill LaBell, Dennis Leopold, Doug McDowell, Tony Ozanich, Dave Parker,

Nancy Parker, and Dana Richter), Richard Kahn, Roberta Kahn, Keweenaw County Historical Society (Virginia Jamison), Andrew Lahti, Mike Lahti, Doug Lancour, Larry Lankton, Library of Congress, Ken Linna, Michael Lorence, Dave Lucchesi, Deb Mann, Josephine Marshall, Merrill Publishing Associates (Tom Burg), Paul Nelson, OHM Advisors (Tracie Williams and Samantha Schutz), Doug O'Hara, Bob O'Neill, Tim Perrigo, Lee Perry, Peter White Public Library (Diana Menhennick), Paul Petosky, Portage Health (Glenn Patrick, Mike Babcock, Victor Harrington, and Chris Walls), Jack Reiss, Mary Roy, Dave Sakari, Nancy Sanderson, Gordy Schaaf, Ken Seaton, Mike Shanahan, Sisters of St. Joseph of Carondelet (Sr. Jane Behlmann), Smithsonian Institution (Kay Peterson), Bill Sproule, Virginia Sullivan, Superior National Bank & Trust (Judy Usitalo), Superior View (Jack Deo), Jeff Thiel, University of Michigan William L. Clements Library (Clayton Lewis, Diana Sykes), John Vaara, Eva Vencato, Kristin Vichich, Tom Vichich, Chuck Voelker, and Zion Lutheran Church (Cheryl Hendrickson, Norma Nominelli, and Marc Tumberg).

Lastly, I would not be who I am without the amazing family that God has blessed me with: Megan and our future historians, Maggie and Jack. Thank you, with love.

INTRODUCTION

On December 14, 1836, at the "Frostbitten Convention" in Ann Arbor, Michigan, delegates voted to accept the terms established by the US Congress for Michigan's statehood. Michigan delegates had previously declined the offer because of the requirement that Michigan cede land known as the Toledo Strip to Ohio in exchange for the majority of the Upper Peninsula. Having relented, Michigan became the 26th state in the union on January 26, 1837. The general feeling was that Michigan lost this compromise, as the Toledo area, including the Maumee River, was more desirable than the "sterile region on the shores of Lake Superior destined by soil and climate to remain forever a wilderness." This opinion would soon change.

In the 1840s, pure, native copper triggered the nation's first mining boom in Michigan's western Upper Peninsula. Copper fever became an epidemic, and the number of speculative mining companies grew rapidly. Most ventures failed, some succeeded, and few thrived. The latter includes the Quincy Mining Company.

Hancock owes its existence to copper mining in general and to Quincy in particular. James A. Hicks, Quincy's first treasurer, purchased all 640 acres of Section 26, T55N, R34W, from the United States in 1848. Adjacent land was obtained by Quincy's first agent, C.C. Douglass. By 1859, the company's growing success warranted the platting of a small village on these parcels at the base of the hill their operations centered on. Agent Samuel W. Hill—of "What the Sam Hill!" fame—oversaw the layout of four streets running east-west and three streets running north-south.

The town was platted as the Village of Hancock, presumably named for John Hancock, the first to sign the Declaration of Independence. Hancock sits on the northern shore of Portage Lake, part of a 22-mile waterway utilized for Lake Superior shipping. In the early years, the waterway was the primary transportation corridor. The first bridge spanning Portage Lake and connecting Hancock to southern neighbor Houghton was not fully operational until 1876. By this time, the shipping lane extended to Lake Superior on both the east and west, isolating Hancock and a few other communities on what is affectionately known as Copper Island. Passenger trains did not cross Portage Lake until 1886, after a second level was added to the existing bridge for rail traffic.

Hancock's early residents were predominantly immigrants from Prussia (a term used loosely to include much of the German Confederation), Ireland, and Cornwall, England. Most came to work in the copper mines or in ancillary industries, such as lumber. Others were merchants, and Hancock was soon bustling with general stores, groceries, apothecaries, banks, boardinghouses, churches, schools, and more. An extensive community was forming, but at its core it was a rough-and-tumble mining town, and saloons were plentiful. An 1863 business directory lists six saloons. By 1875, there were 28.

Hancock became a self-governing municipality on March 10, 1863, when the first village officers were elected, including Hervey C. Parke as president. Parke was a Michigander of English heritage. He owned a hardware store before moving to Detroit and incorporating Parke, Davis & Company, which became a world leader in pharmaceuticals.

Germans, Austrians (often used broadly to include Slovenians and Croatians), and French Canadians were also part of the early ethnic mix. They were soon joined by Finns, Scandinavians, and Italians. Hancock was home to a diverse yet segregated population, and many churches and social organizations were formed to serve specific ethnic groups. An 1887 community guide stated, "Cosmopolitan in its nature Hancock is interesting in itself, apart from the interest attached to it as the center of the greatest copper region in the world."

On March 9, 1903, residents voted to make Hancock the first city in the Copper Country, and the incorporation papers were filed with the state a week later. Canadian-born Archibald J. Scott, the incumbent village president, became the city's first mayor.

Hancock's population mimicked the growth and reduction in local mining activity. Quincy's production and employment peaked around 1910, with the city's population topping out at roughly 9,000. Following a few stops and restarts, Quincy shut down its underground operations for good in 1945. Hancock's population has remained relatively stable since then, totaling between 4,300 and 5,300 in each decennial census.

This book is not a complete history of Hancock. It features a variety of visual snapshots of Hancock's past, predominantly pre-1940, and attempts to capture as much history related to the images as space allows. The most challenging aspect of the book's development was accepting that there is an abundance of interesting Hancock history that could not be included.

One

EARLY MAPS

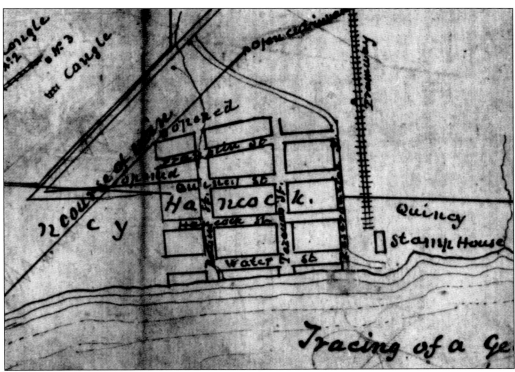

This portion of a November 1859 diagram by Quincy Mining Company agent Samuel W. Hill shows the village of Hancock as laid out by Hill earlier that year. Ravine, Tezcuco, and Reservation Streets run north and south. Water, Hancock, Quincy, and Franklin Streets run east and west. Reservation Street is so named because Quincy reserved all land east of it for its own use. (Library of Congress, HAER MICH, 31-HANC,1--1.)

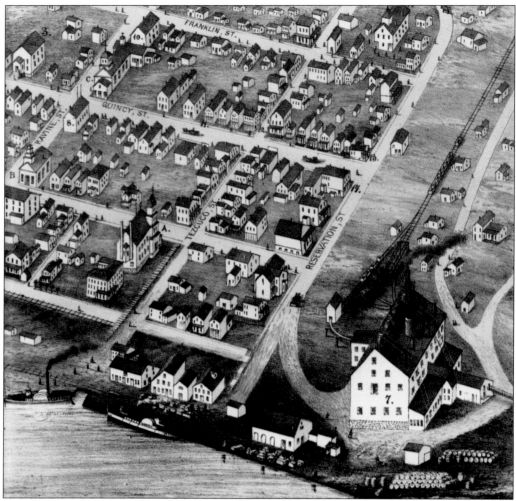

This section of an 1873 American Oleograph Company print shows the core of a rebuilt Hancock following the devastating 1869 fire that claimed roughly three quarters of the town's structures. Prominent in the foreground is the Quincy Mining Company's stamp mill (labeled "7"), serviced by a tramway running from the mining operations on Quincy Hill. Arriving by boat and disembarking at Tezcuco Street was the common means of reaching the village. Notable buildings include the First Congregational Church ("A"), at the southwest corner of Hancock and Tezcuco Streets; the Methodist Episcopal Church ("B"), at the northeast corner of Hancock and Ravine Streets; St. Anne's Catholic Church ("C"), at the northeast corner of Quincy and Ravine Streets; and the public school, near the east end of Franklin Street. St. Anne's Catholic School ("10") is at the southeast corner of Franklin and Ravine Streets, directly behind the church. (Library of Congress, HAER MICH,31-HANC,1--141.)

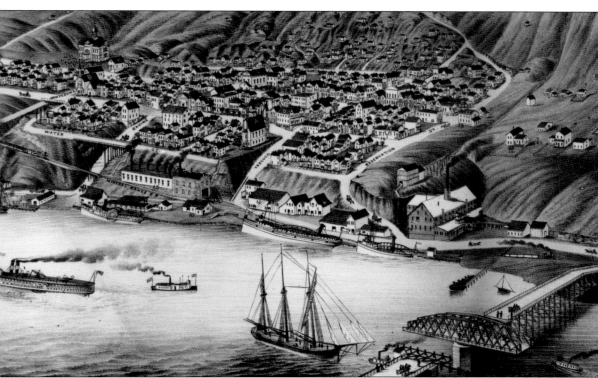

This segment of an 1881 lithograph by Beck and Pauli of Milwaukee, Wisconsin, details a bustling community and accurately represents the slope of the land moving north from Portage Lake. A wooden swing bridge connects Hancock to Houghton on the southern side of the waterway. The Mineral Range Railroad runs primarily between Hancock and Calumet to the north, as rail lines had not yet been added to the bridge. Mineral Range has several structures, including a depot and machine shop, at the base of Tezcuco Street. Hancock's first fire hall (labeled "13") sits at the end of Quincy Street, just east of Reservation Street. The public school ("E"), built in 1875, towers over Quincy Street near the upper left of the image. The newly erected St. Peter and St. Paul's Evangelical Lutheran Church ("B") is at the corner of Hancock and Montezuma Streets, and the former church, adjacent to the east, is used as a school. (Library of Congress, HAER MICH,31-HANC,1--142.)

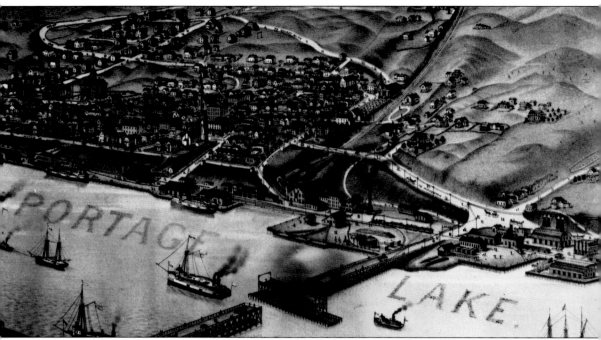

This 1890 bird's-eye view was published by B.H. Pierce & Company of Hancock. The bridge now includes tracks on the lower level, connecting Hancock to the south by rail. The Catholic parish, formerly known as St. Anne's, has divided into two, with the Irish occupying St. Patrick's Church (labeled "3") in the center of town while the Germans constructed St. Joseph's Church ("2") a couple of blocks down the street, just west of the public high school. Parish schools are adjacent to each church. The Finnish Evangelical Lutheran Church ("6") is on Reservation Street, just to the west of the Quincy tramway. At this time, Quincy was in the process of moving their copper-stamping operation to a new mill on Torch Lake, six miles to the east, in response to concerns over the amount of stamp sand being dumped into Portage Lake. (Library of Congress, HAER MICH,31-HANC,1--143.)

Two

THE FIRE OF 1869

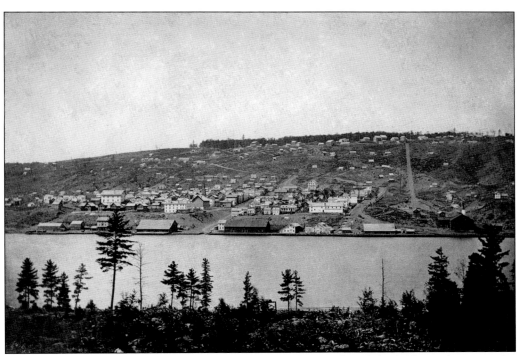

This mid-1860s view looking north across Portage Lake shows a densely built Hancock prior to the 1869 fire. From left to right are Tezcuco Street, Reservation Street, and Quincy's tramway running downhill to their stamp mill on the waterfront. (Houghton County Historical Society.)

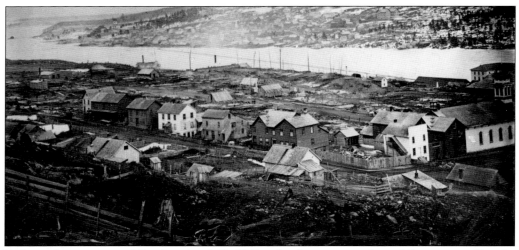

Early in the morning of Sunday, April 11, 1869, a fire began in a saloon following an all-night dance. The saloon was in the northwest quarter of town adjacent to St. Anne's Catholic Church (far right). The fire spread southeast, destroying roughly three-fourths of the community. Directly behind the church are the St. Anne's rectory and school. (Michigan Technological University Archives and Copper Country Historical Collections.)

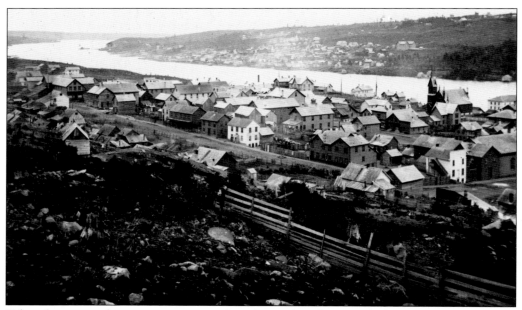

Taken from a similar vantage point to that above, this photograph shows a rebuilt Hancock around 1870, including the First Congregational Church, facing north at the corner of Hancock and Tezcuco Streets. (Michigan Technological University Archives and Copper Country Historical Collections.)

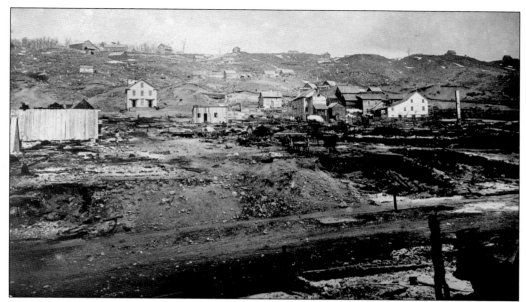

This image depicts the east side of Hancock shortly after the fire. The building standing alone to the left is the public school on Franklin Street. The village's fire equipment and water supply were woefully inadequate to contain the blaze, which lasted about six hours and consumed some 150 structures. (Michigan Technological University Archives and Copper Country Historical Collections.)

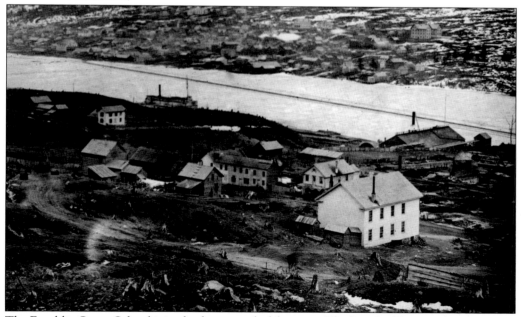

The Franklin Street School is in the foreground of this view. The long building on the waterfront is Quincy's stamp mill. Firefighters from Houghton attempted to cross the frozen lake and lend aid, but many turned back, fearing that burning embers carried by the wind might spread the fire to their community. (Michigan Technological University Archives and Copper Country Historical Collections.)

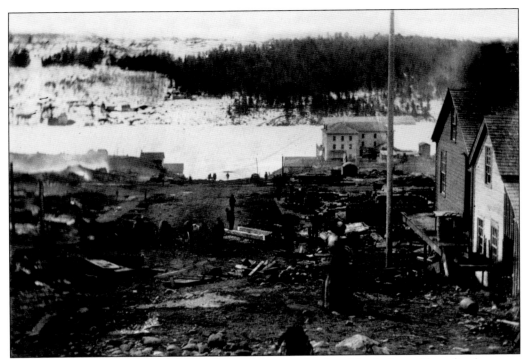

This view looks south down Tezcuco Street following the fire. The L-shaped boardinghouse to the left of the utility pole stood behind the First Congregational Church, which was destroyed. A newspaper account stated, "It was the most awful spectacle we ever witnessed. The flames roared like an approaching tornado, and crackled like the discharge of straggling volleys of small arms." (Houghton County Historical Society.)

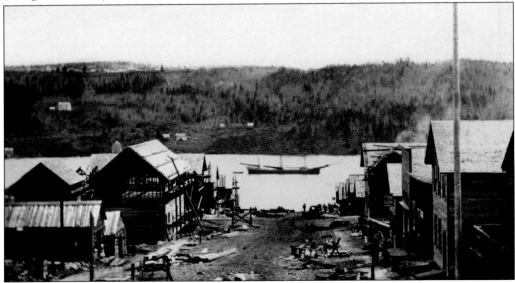

Later in 1869, Tezcuco Street and the rest of Hancock were busy with new construction. A large firefighting unit was soon formed, and the first dedicated fire hall was erected in 1875. (Houghton County Historical Society.)

Three

TEZCUCO STREET

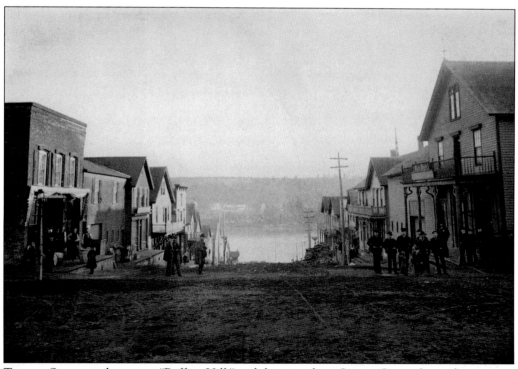

Tezcuco Street was known as "Puffing Hill," and this view from Quincy Street shows the vigorous climb from Portage Lake. On the far left is Joseph Wertin & Sons general store, which is part of a community arts center today. On the far right is Baer Bros. meat market, which burned down in 1923. Jacob Baer served as village president from 1893 to 1897. (Author's collection.)

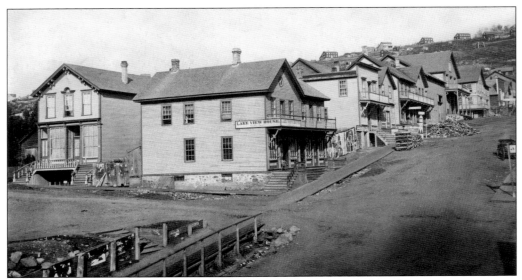

Opened at the corner of Hancock and Tezcuco Streets in 1871, the Lake View House was conspicuous among the village's hotels. At the north end of the block, the last building with a second-floor deck is Baer Bros. market, followed to the right by the Hancock House. Out of frame to the lower left is the site of the First Congregational Church. (Houghton County Historical Society.)

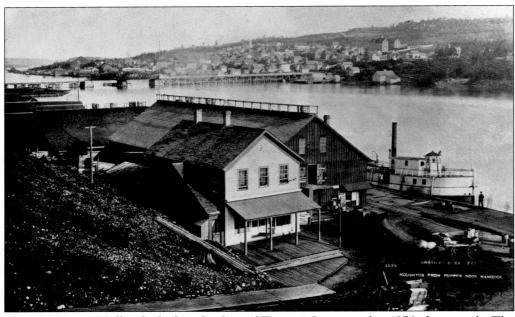

The steamer A. *Neff* is docked at the foot of Tezcuco Street in this 1876 photograph. The Mineral Range Railroad then consisted of 13 miles of line from this terminus in Hancock north to Calumet. It primarily carried cargo but also ran three passenger trains daily. The original wooden swing bridge connecting Hancock to points south is visible in the background. (Jack Deo-Superior View.)

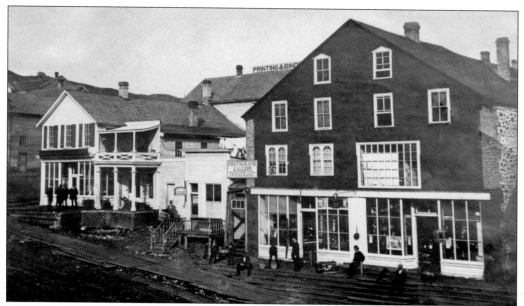

Seen on Tezcuco Street's first block around 1875 is the J. Pinten & Bro. photography studio and hardware store. The small building to the left of the Pintens' is the first office of Dr. Joseph E. Scallon, who served the community as a physician and surgeon for nearly 50 years. Scallon was village president from 1891 to 1893, and Scallon Street is named for him. (Houghton County Historical Society.)

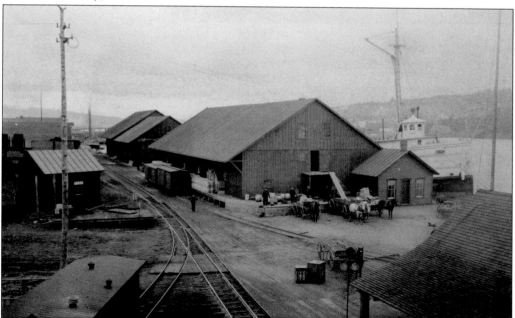

The foot of Tezcuco Street was still a hub of activity in the 1890s. James A. Close's new warehouse is larger than its predecessor (seen on the opposite page) and is now on the other side of the Mineral Range tracks. The rail lines extend south over the bridge via a lower level. The steamer *Joseph L. Hurd* is seen at the dock. (Author's collection.)

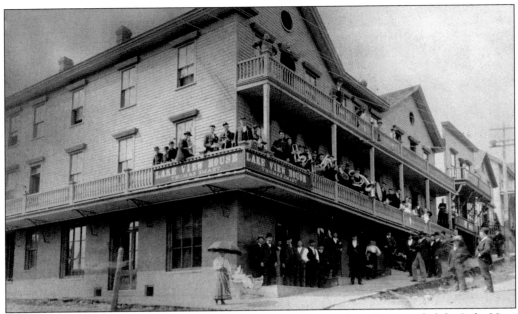

Owner Thomas Smart, village president from 1888 to 1891, significantly expanded the Lake View House in 1881. With room for 60 guests, it became the most ample hotel in town. Later known as the International House and Hotel Salo, the Lake View House was the first home in the new world for many immigrants. It was demolished in the 1940s. (Houghton County Historical Society.)

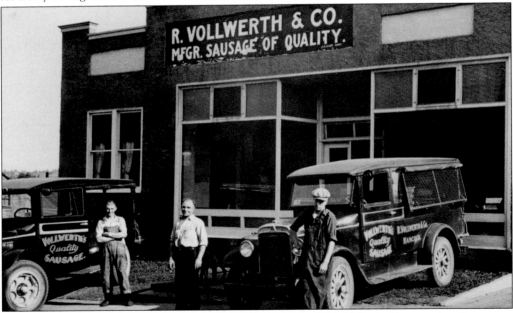

Richard Vollwerth began his sausage-making enterprise in 1915. Vollwerth's moved to the corner of Hancock and Tezcuco Streets, former site of the First Congregational Church, in 1922. The company remains at this location, pictured here around 1928, to this day. They also maintain a storage building across the street where the Lake View House once stood. (Michigan Technological University Archives and Copper Country Historical Collections.)

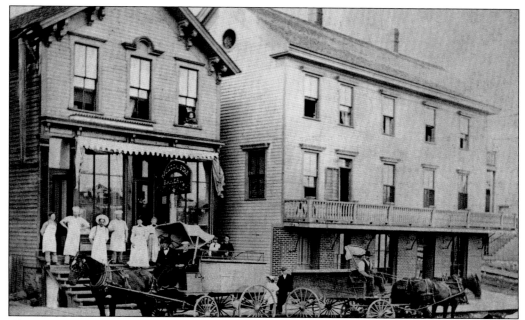

The Hancock Star Bakery was opened by August Tangen and Albert Nelson around 1896. It was located on Hancock Street adjacent to the Lake View House. Hancock has been home to many notable bakeries over the years, the first being Hoffenbacher's on Quincy Street. (Author's collection.)

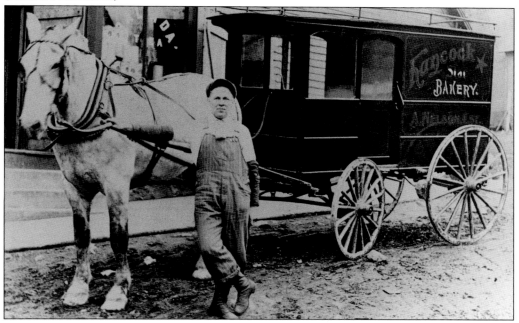

Following Albert Nelson's death in 1912, the Hancock Star Bakery was operated by his estate. During the 1900s and 1910s, the business had a retail outlet on Quincy Street and utilized their Hancock Street location for wholesale orders. Driver Richard Manning (Manninen) is pictured here with a delivery wagon around 1916. (Houghton County Historical Society.)

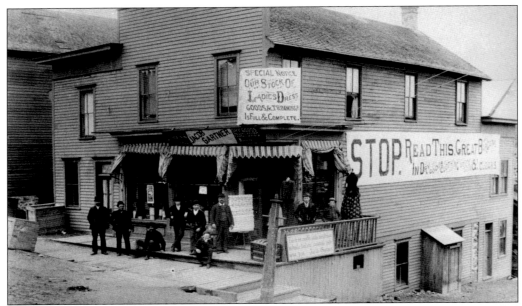

Jacob Gartner and his son Isadore arrived in the Copper Country in the 1880s. They peddled their dry goods throughout the region, eventually saving enough to open a store at the corner of Hancock and Tezcuco Streets. Jacob, seventh from left, is standing near the store's entrance in this c. 1890 photograph. Isadore is fifth from left. (Michigan Technological University Archives and Copper Country Historical Collections.)

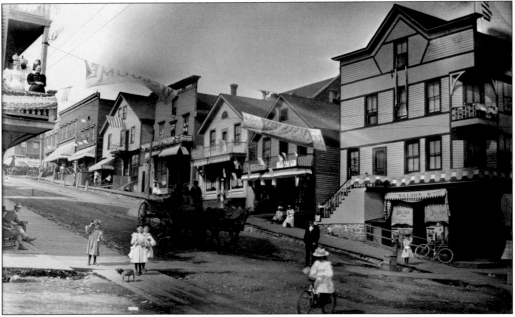

This undated image shows the east side of Tezcuco Street between Hancock and Quincy Streets. Nicholas Evert and Nicholas Dollinger operated the Milwaukee House with Saloon 8 at the corner opposite the Lake View House, whose balcony is visible on the far left. (Michigan Technological University Archives and Copper Country Historical Collections.)

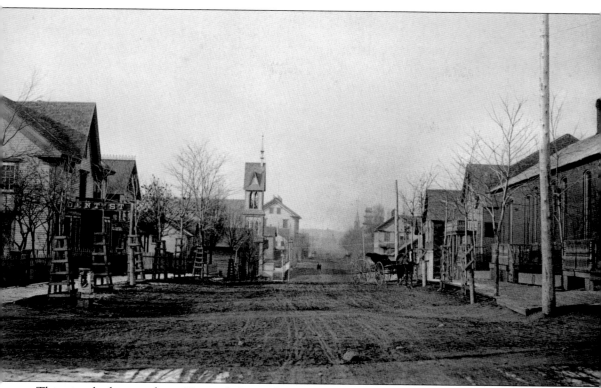

This view looks west down Hancock Street from Reservation Street in about 1886. The dentist office of Wilbur S. Whisler is in the foreground on the left. The house was later home to St. Mary's Hospital from 1896 to 1899 and St. Joseph's Hospital from 1899 to 1904, when a larger St. Joseph's was opened on Water Street. Farther down the south side of the street, the steeple is that of the First Congregational Church, on the corner of Tezcuco Street. The large building beyond it is the Masonic Hall. The three-story, wooden-frame structure was severely damaged by fire around 1929, and was replaced with a two-story, brick building on the same site. Crossing Hancock Street to the northern side, the two steeples seen in the distance are atop St. Peter and St. Paul's Evangelical Lutheran Church and the Methodist Episcopal Church. The building seen just above the horse and buggy is Lake View House, at Tezcuco Street. On the far right, at the corner of Hancock and Reservation Streets, is the original First National Bank. (Author's collection.)

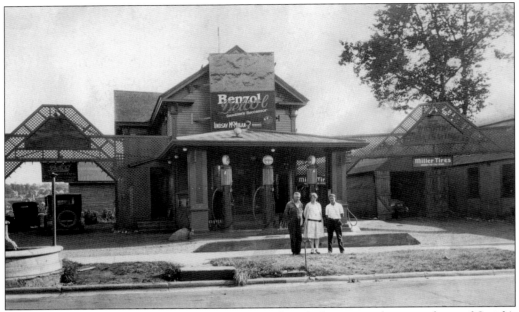

Owners John (left) and Sophie Smith and an unidentified man are shown in front of Smith's Super Service Station around 1930. The main building, at the corner of Hancock and Reservation Streets, was previously the home of Jacob Baer. These structures are gone, but the location remains a gas station, with a convenience store, today. (Mary Pekkala.)

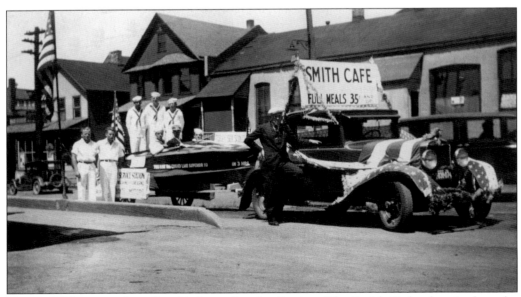

This c. 1935 view is from Smith's Super Service Station. The Smith Cafe advertised on the automobile was an eatery on Quincy Street. The speedboat contains members of the Ripley Sea Scouts. Across the street on the right is the original location of Hancock's First National Bank. The house directly to the left of it, seen behind the sailors, still stands today. (Mary Pekkala.)

Four

QUINCY STREET

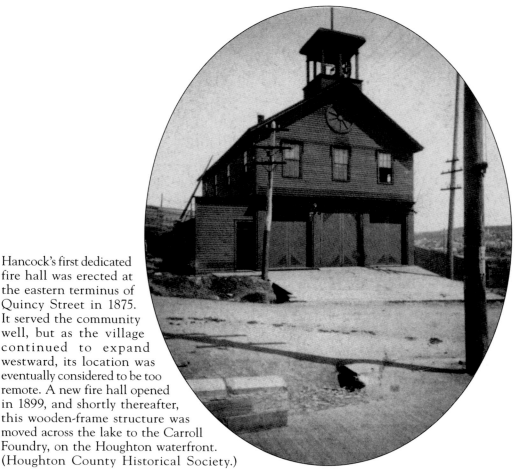

Hancock's first dedicated fire hall was erected at the eastern terminus of Quincy Street in 1875. It served the community well, but as the village continued to expand westward, its location was eventually considered to be too remote. A new fire hall opened in 1899, and shortly thereafter, this wooden-frame structure was moved across the lake to the Carroll Foundry, on the Houghton waterfront. (Houghton County Historical Society.)

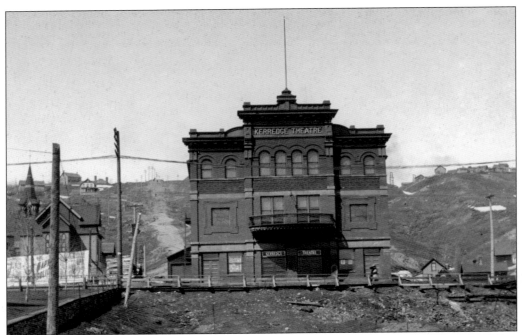

The Kerredge Theatre was built in 1902 by the father-and-son tandem of William and Ray Kerredge, owners of a local hardware store. It is seen here in 1904, with the original Finnish Evangelical Lutheran Church to the far left. The path on the hill between the church and the theater is the site of the old Quincy tramway. (Michigan Technological University Archives and Copper Country Historical Collections.)

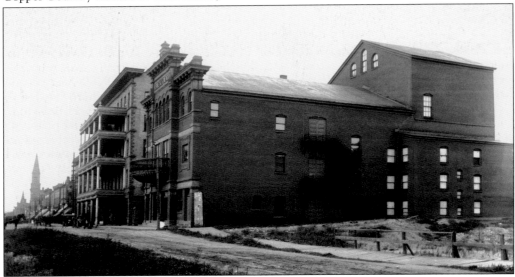

After the original fire hall was removed, Quincy Street was extended east one block from Reservation Street to West Street (now Dunstan Street). The Kerredge Theatre, a massive brick structure, occupied the middle of the block. This c. 1915 view is looking west, with the Scott Hotel adjacent to the theater. (National Park Service, Keweenaw National Historical Park, Myrno Petermann Glass Plate No. 379.)

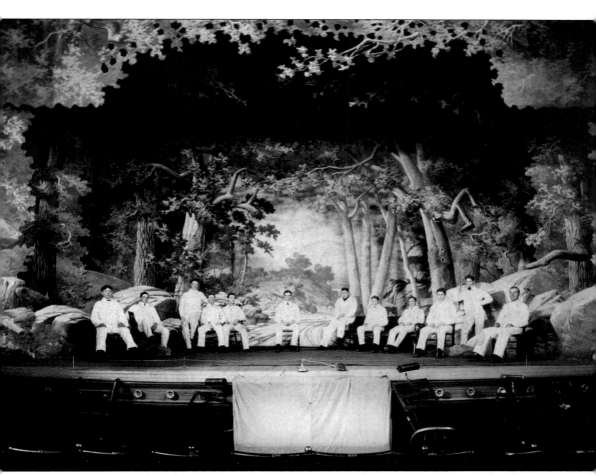

At its peak, the Kerredge Theatre seated over 1,500. The stage staff is shown in this early interior view. From left to right are Edgar Richards, Jacob Keiler, Gus Flynn, Edward Rentenbach, Joseph Raymond, Joseph Moyle, A. Meyers, J. Merrick, hockey star Joseph Linder, Edward Lee, Joseph McKercher, and Edward Reidy. Notable performers who graced the stage include Sarah Bernhardt, Enrico Caruso, and John Philip Sousa. The Kerredge Theatre burned down in the early morning hours of May 29, 1959. Roughly 500 spectators watched the final drama unfold as local fire crews battled the blaze. The adjacent Scott Hotel was damaged but saved. The theater is remembered fondly by many Hancock residents to this day. The site is now a parking lot and a staging area for community parades. (Author's collection.)

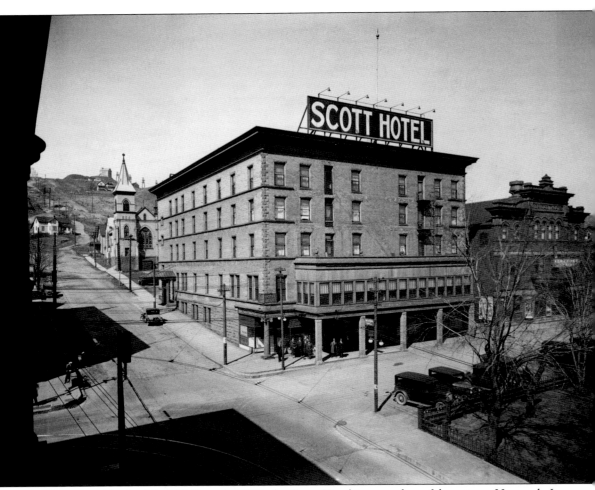

Completed by Archibald J. Scott in 1906, the Scott Hotel is an anchor of downtown Hancock. It was built as a monument to the importance of Hancock, which had become the Copper Country's first city in 1903, and benefited from its proximity to the Kerredge Theatre. This 1920s photograph shows one of many fronts worn by the Scott over the years. Behind the hotel is the second Finnish Evangelical Lutheran Church, and some architectural features of the Wright Block are seen on the far left. Save for the Kerredge Theatre, all of the buildings mentioned here still stand today. The Scott Building is now an apartment complex, with three commercial spaces on the first floor. Like the building that bears his name, A.J. Scott is a Hancock icon. He was village president from 1897 through 1903 and the city's first mayor in 1903–1904. He again served as mayor from 1906 to 1909, and Scott Street is also named for him. (Michigan Technological University Archives and Copper Country Historical Collections.)

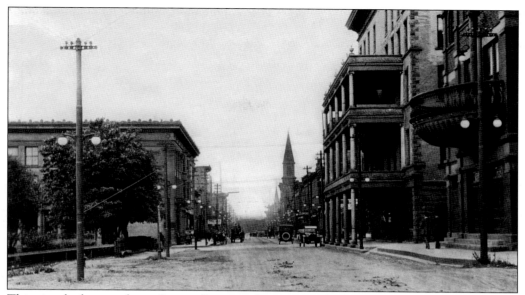

This view looks west down Quincy Street in about 1918. The balcony of the Kerredge Theatre is seen at the far right, next to the pillared front of the Scott Hotel. To the far left is the Wright Block, built at the corner of Quincy and Reservation Streets in 1900 to house Superior Savings Bank and Jacob Gartner's store. (Bill Schoos.)

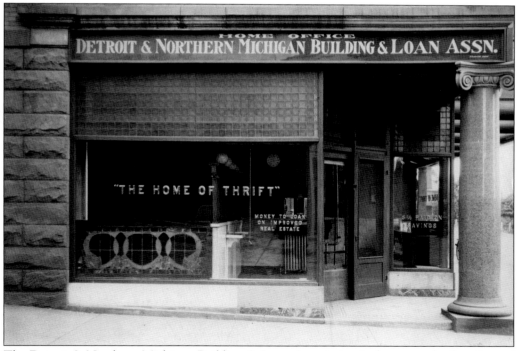

The Detroit & Northern Michigan Building & Loan Association is shown on the first floor of the Scott Hotel around 1920. Founded in Hancock in 1889, the company, later known as D&N Bank, merged with Republic Bank of Lansing, Michigan, in 2000. The location shown here is now a restaurant, and the entrance looks very much the same. (Andrew Lahti/Dave Sakari.)

This photograph looking across Reservation Street and down Quincy Street's 100 block from the front of the fire hall was likely taken in 1890. The former Holland, Cardell & Company hardware store is about to receive a face-lift. The post office was located here in the early 1880s, with Morton L. Cardell serving as postmaster. (Michigan Technological University Archives and Copper Country Historical Collections.)

The Superior Savings Bank opened here in 1890 with a new facade. This building was demolished to erect the Wright Block in 1900. The bank, now Superior National Bank & Trust, remains on Quincy Street to this day, roughly two blocks west of this original location. (Michigan Technological University Archives and Copper Country Historical Collections.)

This handsome stone building stood at the northwest corner of Quincy and Reservation Streets. Shown here around 1887, it housed Hancock's only newspaper at that time, the *Copper Herald*. The publication survived many name changes, the longest-tenured being the *Evening Copper Journal*. Earlier in the 1880s, this building housed the *Northwestern Mining Journal*, which was printed on-site on steam-powered presses. (Houghton County Historical Society.)

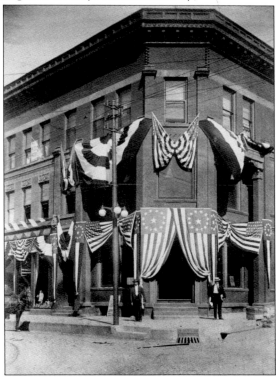

The publishing building shown in the previous photograph was replaced by the First National Bank in 1888. It was originally a two-story structure with an ornate cornice atop the entrance, which faces the intersection. The cornice was sacrificed when a third floor and 40 feet on the north side were added to the building in 1903. Since then, its appearance has remained virtually unchanged. (Superior National Bank & Trust.)

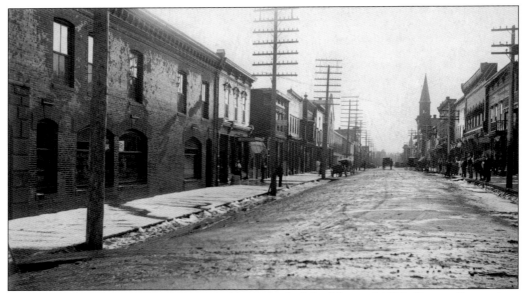

Much of the Superior Savings Bank is visible on the far left of this mid-1890s Quincy Street view. Next door, a man sweeps snow from the sidewalk in front of F.C. Haefer's photography studio. On the opposite side of the street, the nearest steeple sits atop St. Patrick's Catholic Church. Wooden boardwalks connecting the unpaved street to the sidewalk were utilized throughout the town. (Houghton County Historical Society.)

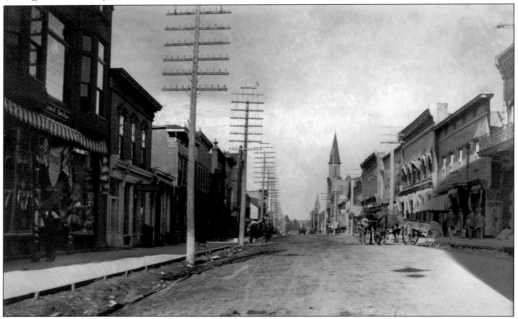

On the far left, a man sweeps in front of the new Jacob Gartner department store, which moved to Quincy Street from Hancock Street in 1900. The men at the far right, behind the camera-shy horses, appear to be inspecting an advertisement for the Ringling Bros. Circus, which came to town that summer. (National Park Service, Keweenaw National Historical Park, Andrew C. Curto Collection, Album No. 14, Image No. 058.)

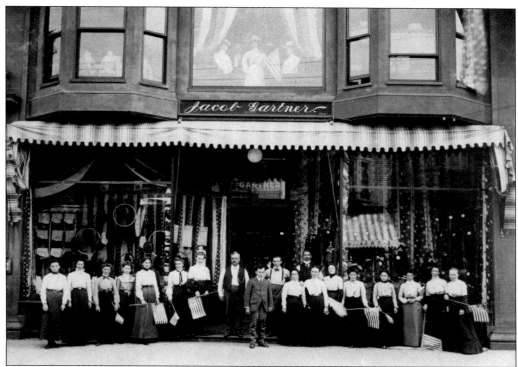

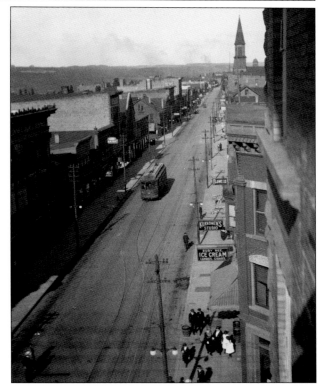

Jacob Gartner (middle, wearing vest) and others pose in front of the Quincy Street store. Gartner expanded immediately to the west in 1907, and this building, which is still prominent in downtown Hancock, was given a blue Vitrolite facade in 1952. The department store remained in the Gartner-Kahn-Reiss family for over a century. (Michigan Technological University Archives and Copper Country Historical Collections.)

An expanded Gartner's is seen on the far left of this photograph taken from a Scott Hotel balcony around 1920. The next three-story building, just beyond the streetcar, is the Epstein Block, built around 1906. Home to the Twin City Commercial College at the time of this image, it has recently been remodeled with commercial space on the first floor and residential space above. (Jack Deo-Superior View.)

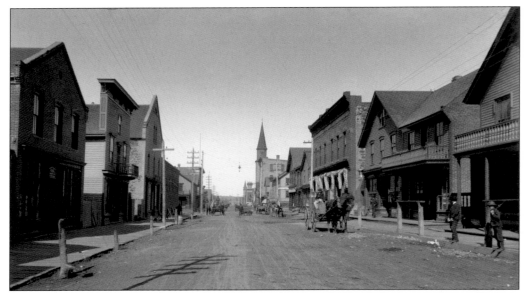

Pictured third from the left in this c. 1889 photograph is Peter Ruppe & Sons general store. Directly across the street is Edward Ryan's general store. In addition to being leading merchants, Ryan (1867–1868 and 1879–1888) and Ruppe (1874–1875) both served as village president. Benjamin Wieder's harness shop is on the far right. (Michigan Technological University Archives and Copper Country Historical Collections.)

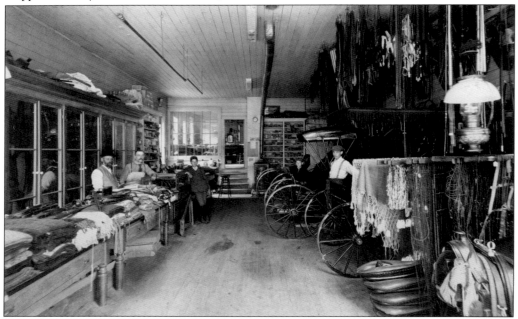

Benjamin Wieder Sr., far left, began his harness-and-buggy company in Hancock in 1867. He remodeled his wooden storefront, seen in the previous photograph, into a brick building in 1892. The company transitioned into a Goodyear tire dealership in 1914, which Wieder's son Ben E. Wieder (far right) operated until 1959. The interior of the harness shop is shown here around 1895. (Houghton County Historical Society.)

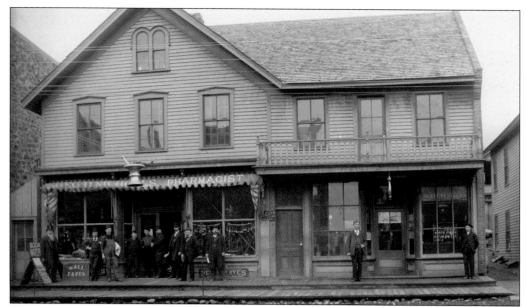

George H. Nicholls's pharmacy and Edward Waara's watchmaker shop are seen around 1890. The middle door leads to the second-floor office of Michael Finn, justice of the peace. Finn was village clerk/recorder from 1867 to 1903 and city clerk in 1903–1904. His office often served as the village hall prior to 1899, and Hancock's Finn Street is named in his honor. (Michigan Technological University Archives and Copper Country Historical Collections.)

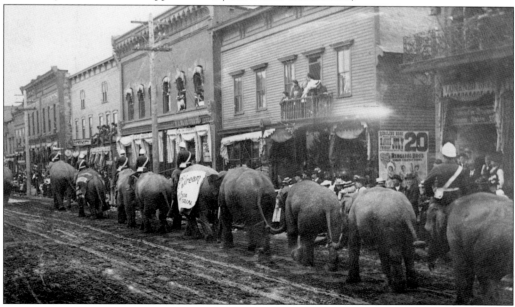

Ringling Bros. elephants parade through town on July 20, 1900. Behind the nearest utility pole is the remodeled Wieder building. To the left is the former site of Nicholls's pharmacy, also remodeled, followed by Ryan's store. The Ringling Bros. traveling show also visited Hancock in 1899, 1902, and 1912. (Michigan Technological University Archives and Copper Country Historical Collections.)

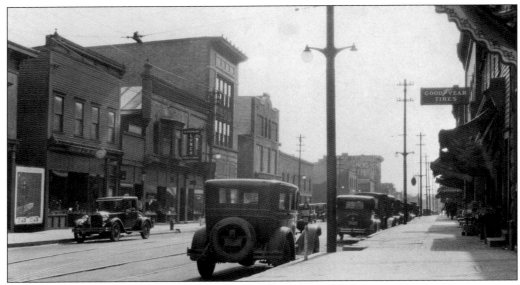

Frank C. Mayworm's jewelry store is at the far left of this c. 1925 image. The building is now a bridal and formal wear shop. To the right of Mayworm's are the Cloverland Lunch, which was later lost to fire, the Epstein Block, and the old Ruppe building (shown here as part of the Gartner Furniture Company). The latter now houses a sporting goods outfitter. (Mike Shanahan.)

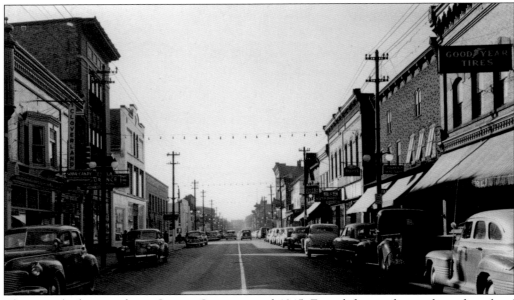

This view looks west down Quincy Street around 1945. From left to right on the right side of the street are United Cigars, which now houses a party store; S&S Auto Parts, still home to an auto-parts retailer; Pulkkinen's shoe shop, currently vacant and undergoing renovations; and Wieder's tire store, which now houses a bike shop. Today, this section of Quincy Street is part of US Route 41 and is one-way traveling west. (Bill Schoos.)

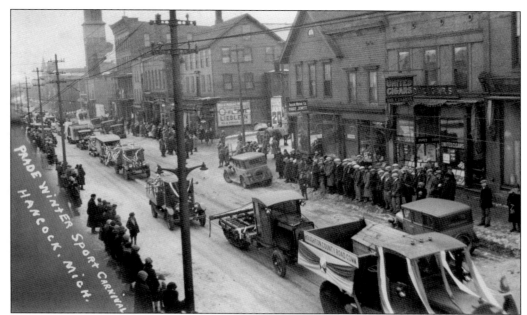

This appears to be the inaugural Michigan College of Mining and Technology (now Michigan Technological University, or Michigan Tech) Winter Carnival parade of 1928. To the left of United Cigars at the corner of Quincy and Tezcuco Streets is the Siller Motor Company. A car, likely a late-model Paige-Jewett, is seen in their showroom. Today, the building is home to a formal wear and alterations shop. (Joseph Meinardi family.)

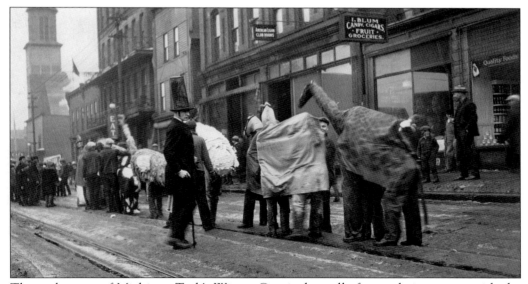

The early years of Michigan Tech's Winter Carnival usually featured circus acts, with the students performing all roles, including those of the animals. Here, some of the attractions parade past Isadore Blum's fruit market. St. Patrick's Catholic Church is seen at the far left. (Joseph Meinardi family.)

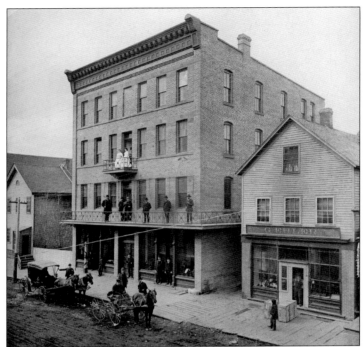

A landmark of Quincy Street's 200 block, the Northwestern Hotel became Hancock's grandest structure upon its completion in 1886. It was frequently called the "New Northwestern Hotel" in its early years to distinguish it from a predecessor on the same site. It is seen here around 1890 with George Ehler's boot and shoe store on the right and Dennis Coughlin's residence on the left. (Author's collection.)

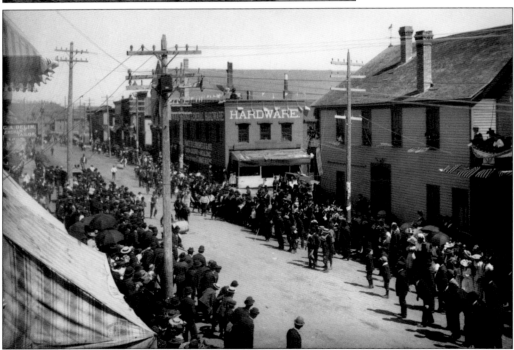

A large crowd is watching men roll barrels down Quincy Street during the July 4, 1894, celebration. This view from the Northwestern Hotel looks east to the Tezcuco Street intersection. William Kerredge's hardware store is at the corner with a couple of spectators perched atop it. (Michigan Technological University Archives and Copper Country Historical Collections.)

The Northwestern Hotel, also known as the Linder Block, was a four-story brick structure. Featuring 50 rooms, steam heat, electric lighting, and hot and cold water in the baths, it was lauded in the 1880s as having greater advantages than any other hotel in the Copper Country. Pictured here around 1897, the building was demolished in the 1990s. (Michigan Technological University Archives and Copper Country Historical Collections.)

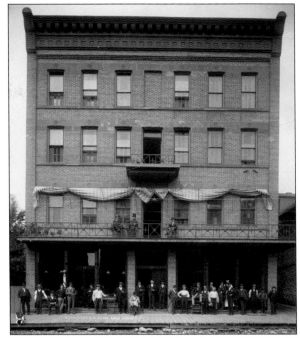

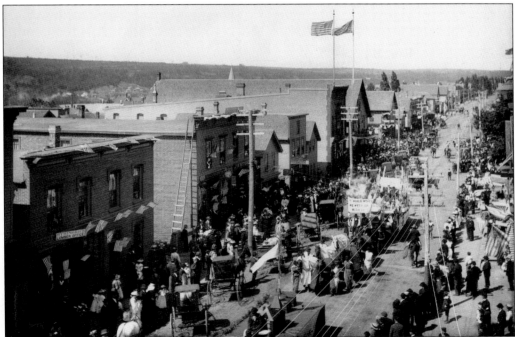

Looking west from the Northwestern Hotel, this view shows the end of the July 4, 1894, parade. Stringer's lumber office is on the far left. At the end of the block, with the second American flag atop, is St. Patrick's Hall. It was the meeting place for numerous social societies and arguably Hancock's premier playhouse prior to the Kerredge Theatre. (Michigan Technological University Archives and Copper Country Historical Collections.)

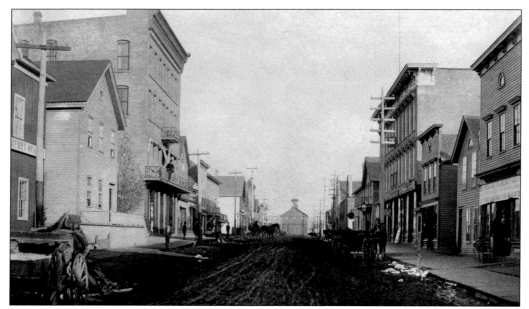

The fire hall is seen at the end of Quincy Street in this 1890 view looking east. From left to right are Coughlin & Son's livery stable, the Coughlin residence, and the Northwestern Hotel. At the right is Wetzler & Hanauer's general store. Farther down on the right, the three-story building opposite the Northwestern Hotel is the Scott Block. (Michigan Technological University Archives and Copper Country Historical Collections.)

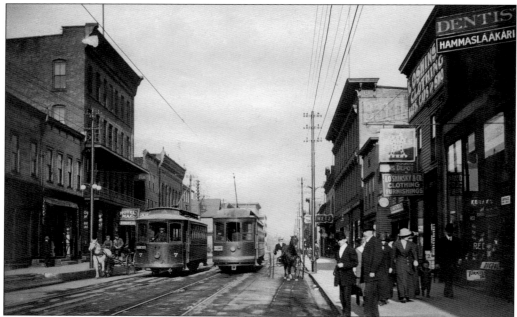

Two streetcars pass each other in front of Hotel Mac around 1910. The Northwestern was briefly known as Hotel Mac under proprietor John P. McAlear. Isaac Oshinsky's clothing store is seen on the right. Note the bilingual sign of dentist Erle C. Hay on the Kauth Block (far right), which attempts to attract Finnish patients. (Houghton County Historical Society.)

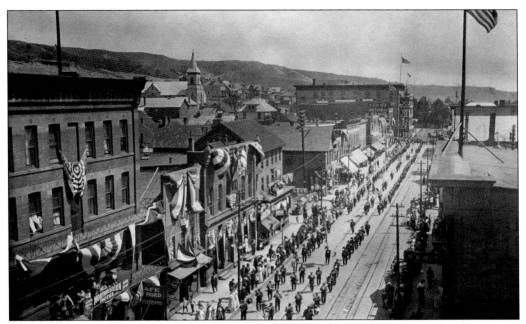

The Northwestern Hotel name was reinstated by the time of this Independence Day photograph taken around 1911. The First National Bank and the Scott Hotel are easily identifiable at the far end of the street. Seen behind the Scott Hotel is the new Finnish Evangelical Lutheran Church on Reservation Street. Clothier Newman A. Metz's sign (lower right) hangs on the Scott Block, also named for A.J. Scott. (Houghton County Historical Society.)

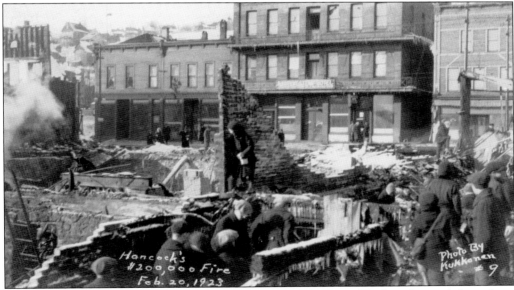

On February 20, 1923, a fire started in the basement of the Scott Block and spread throughout much of Quincy Street's 200 block. It became known as the "$200,000 Fire," based on the estimated damage. Losses included the Scott Block, the Drittler Block, and Baer Bros. meat market, all of which dated to the 1870s. (Michigan Technological University Archives and Copper Country Historical Collections.)

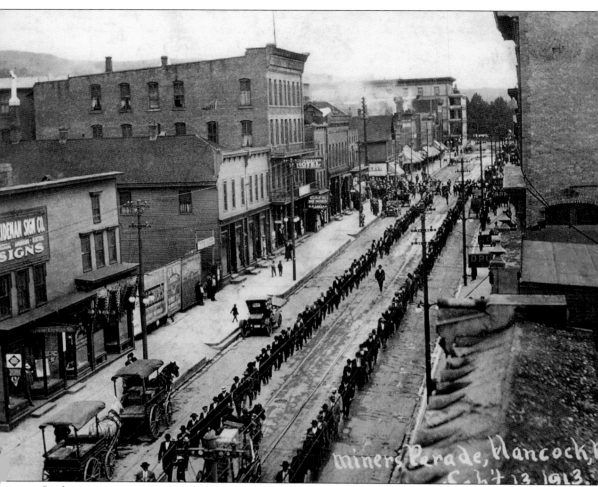

miners Parade, Hancock, Sept 13 1913

Striking copper miners and their supporters are seen parading down Quincy Street in this September 13, 1913, photograph. The Copper Miners' Strike of 1913–1914 is the most notable, contentious, and tragic event in Copper Country history. Thousands of miners left their jobs in July 1913, and they did not agree to return until April 1914. In the interim, the entire district was marred by ceaseless tension and countless acts of violence, including several killings. Although Calumet, 10 miles north of Hancock, was the epicenter of strike activity, incidents occurred in every community. The most memorable event in Hancock took place on December 26, 1913. Two days after Calumet's Italian Hall tragedy, in which over 70 lives were lost, Charles H. Moyer, the president of the Western Federation of Miners, was shot at the Scott Hotel, where he was lodging. The wounded Moyer was then carried over the bridge to Houghton and placed on a train to Chicago by citizens opposed to the strike. (Ken Linna.)

Passersby watch work being done in front of St. Patrick's Catholic Church in 1911. The Seideman Sign Company displays an advertisement for the Yankee Robinson Circus, which was coming to town on June 20 of that year. The 100 through 300 blocks of Quincy Street were added to the National Register of Historic Places on October 13, 1988. (Houghton County Historical Society.)

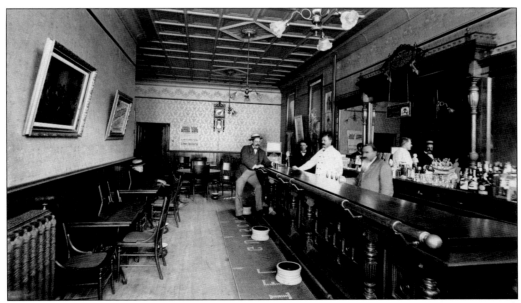

Alexander Gutsch, far right, is seen behind the bar inside of Hotel Gutsch around 1900. Gutsch was in the hotel and saloon business for several decades and had a reputation as an entertaining storyteller who was steeped in local history. The Quincy Street location shown here is now a popular café nearing its centennial at the site. (Houghton County Historical Society.)

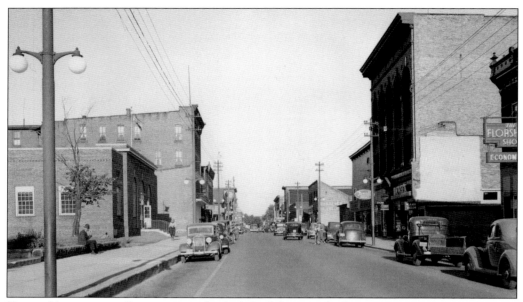

Hancock's new post office is seen at the far left of this view looking east in approximately 1940. The large building on the right is the Kauth Block, built by saloon owner Andrew Kauth around 1901. It was destroyed by fire on August 9, 1944. (Joseph Meinardi family.)

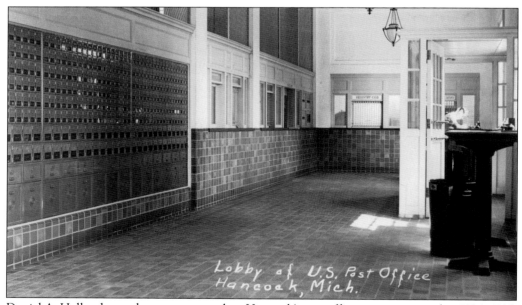

Daniel A. Holland served as postmaster when Hancock's post office was constructed in 1934–1935. The entrance partition has been altered, and the windows on the far wall are no longer in use, but it has otherwise changed very little over 80 years. (Joseph Meinardi family.)

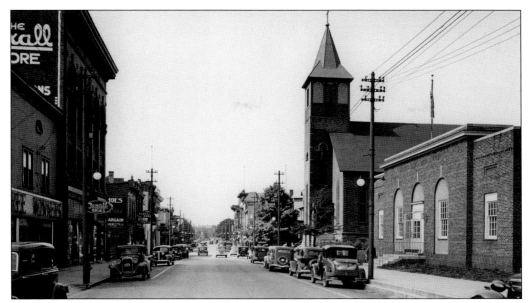

Looking west around 1935, the Kauth Block looms large on the left. The Three Winners store adjacent to it was also lost in the 1944 fire. Across the street and beyond the new post office is St. Patrick's Catholic Church, which burned down on May 6, 1937. Note that there is only one streetlight on each post, as opposed to the two seen on the opposite page. (Joseph Meinardi family.)

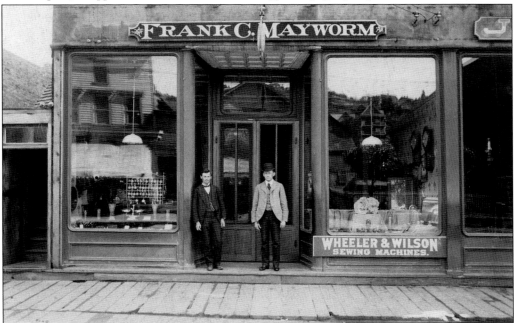

Watchman John Novack (left) and owner Frank C. Mayworm are shown in front of Mayworm's jewelry store in the Holman Block around 1900. Mayworm operated at several downtown locations in a career that spanned over 40 years. The reflections of buildings across the street and beyond are seen in the storefront windows. The far right window is part of John N. Mitchell's furniture store next door. (Houghton County Historical Society.)

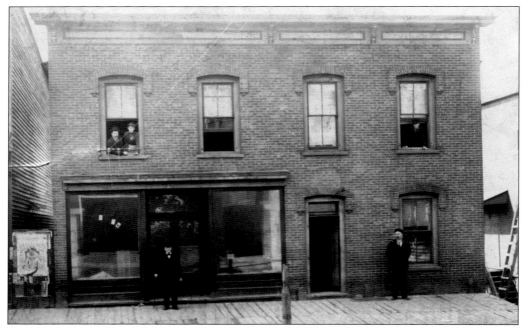

Peter Holman (left) and his son-in-law John N. Mitchell stand in front of the Holman Block in the 1880s. Born in Cornwall, England, Holman arrived in the Copper Country in the 1850s and worked in the mines before opening a grocery in 1864. Mitchell was a longtime furniture dealer on Quincy Street. (Michigan Technological University Archives and Copper Country Historical Collections.)

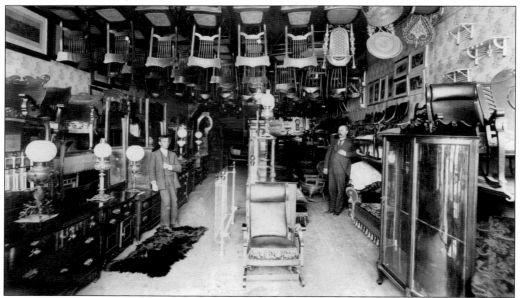

John N. Mitchell (right) and his son Eldred pose inside of Mitchell's furniture store in the 1890s. Like many merchants of the era, Mitchell was adept at maximizing his available space, even hanging inventory from the ceiling. And, like many early Hancock buildings, the Holman Block—later known as the Mitchell Block—was lost to fire. (Houghton County Historical Society.)

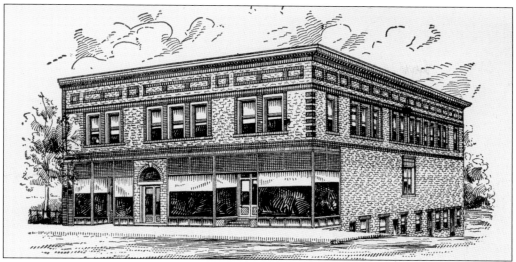

This image appeared on bill head receipts of the Funkey Hardware store in 1906, and the Funkey Block was first listed at this location in a 1907 city directory. The building likely never had this appearance. A much narrower three-story structure of similar design stands at the left end of this property, adjacent to the old Hotel Gutsch. It is home to a local community foundation today. (Author's collection.)

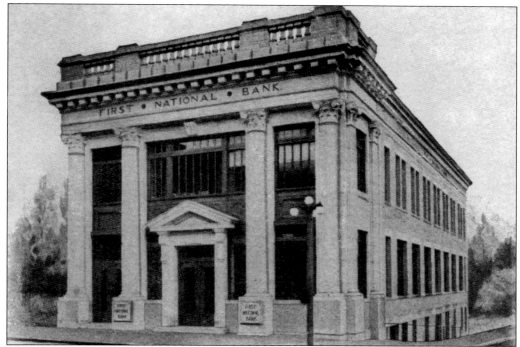

The First National Bank moved from the northwest corner of Quincy and Reservation Streets to this building on the southeast corner of Quincy and Ravine Streets on February 16, 1914. Standing next to the Funkey Block, its appearance has changed little other than the addition of another floor. Having just reached its centennial, it now houses the offices of a financial advisor. (Bill Schoos.)

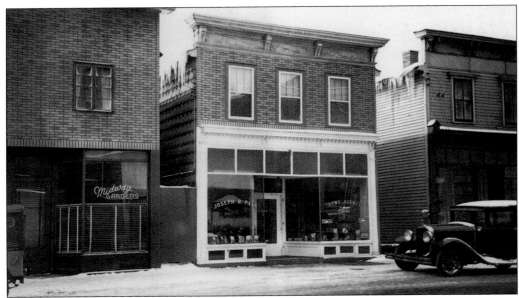

Joseph R. Payn operated two storefronts on Quincy Street's 300 block. The news agency, pictured in this undated photograph, was primarily a wholesale outlet. The retail shop, Payn's News, was on the opposite side of the Midway Gardens restaurant. This news agency building is now home to a paint-your-own pottery studio, and the Midway Gardens space is an antiques and collectibles shop. (Blast From the Past/Ken Linna.)

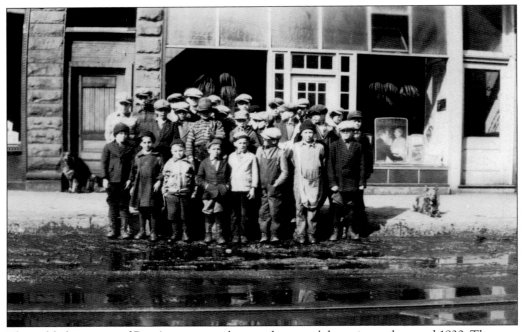

This is likely a group of Payn's newspaper boys and assorted dogs pictured around 1930. They are standing in front of the Rouleau Block, erected in 1903. The corner of Germania Hall is visible on the left. Today, the Rouleau Block is occupied by a sports bar. (Ken Linna.)

This view looks east around 1918. The building on the right with the barber pole and gabled roof was later the site of Payn's News. The light-colored structure farther down the road is the First National Bank, at the corner of Ravine Street. The buildings between the barbershop and the bank were lost to fire on January 14, 1963. (Houghton County Historical Society.)

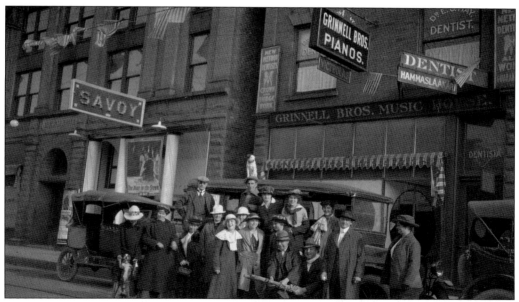

An unidentified group is seen in front of Grinnell Bros. Music House around 1916. The music store and Erle C. Hay's relocated dentist office, still sporting multilingual signage, occupied the Rouleau Block. The group pictured may be the traveling troupe responsible for the play *The Man in the Street*, advertised at the Savoy Theatre in Germania Hall. (Houghton County Historical Society.)

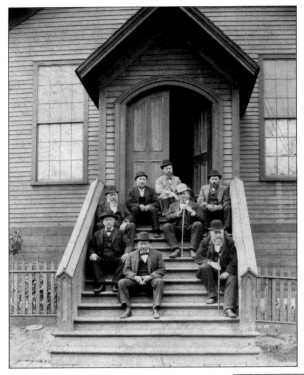

Hancock's German Aid Society was formed in 1859, and Germania Hall, shown here around 1890, was dedicated on September 6, 1873. The hall was torn down in 1906 in favor of a more modern one. The gentlemen seated on the steps are, clockwise from the top, Daniel Kloeckner, Oscar Eliassen, Philip Scheuremann, Joseph Wertin, Joseph Hermann, Joseph Gardner, John Duncan, and Jacob Baer. (Houghton County Historical Society.)

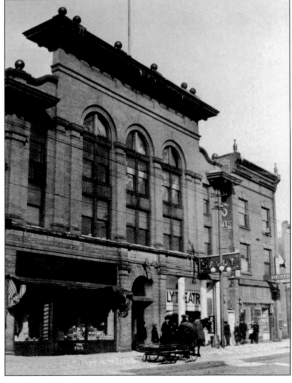

The second Germania Hall was dedicated in January 1907. It was built on the site of the original Germania Hall and is seen here with the Rouleau Block (right) around 1913. The building was renamed Lincoln Hall following World War I. Germania/Lincoln Hall was destroyed by fire on December 4, 1966, and the site is now a parking lot. (Michigan Technological University Archives and Copper Country Historical Collections.)

A young girl is about to receive popcorn at John Meinardi's National Grocery in the 1920s. Victoria Meinardi, John's wife, is standing to the right. The sign above the awning advertises Wear-U-Well brand shoes. This building is now gone, and the site is home to a flower shop. (Joseph Meinardi family.)

John Meinardi, visible in the window, moved immediately to the west and opened Meinardi's Grocery in 1928. The store remained in business until 1975. Today, it is a residence, still owned by the Meinardi family. The side of the National Grocery building is seen at the far left. (Joseph Meinardi family.)

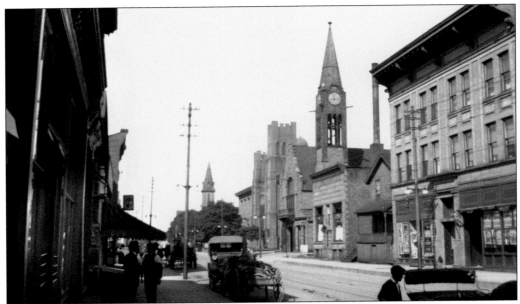

The Schneider Block (far right) was built in 1906. Like its neighbor, Germania Hall, it was designed by local architect Hans T. Liebert. Shown here around 1916, the building is now a restaurant and bar. The site previously contained the childhood home of iconic photographer Edward Steichen in the 1880s, and the City of Hancock erected a historical marker there in 2013. (Houghton County Historical Society.)

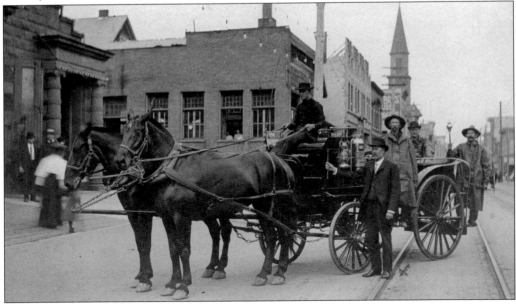

A fire wagon and members of the volunteer fire department, including chief John N. Mitchell (standing closest to the camera), are pictured in front of the fire hall in 1906. Above the wagon, the Schneider Block is seen partially constructed. Advertising is visible on the side of the Rouleau Block, a few lots farther down, as the new Germania Hall had not yet been erected. (Houghton County Historical Society.)

Hancock City Hall was dedicated on February 16, 1899. Led by the Quincy Excelsior Band, village council and fire company members marched down Quincy Street from the old fire hall to the new building. Village president A.J. Scott gave an enthusiastic speech from the back of the hose wagon and then opened the building for the citizens to inspect. (Michigan Technological University Archives and Copper Country Historical Collections.)

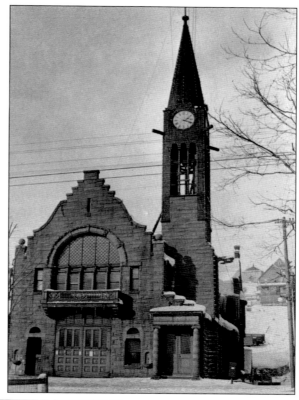

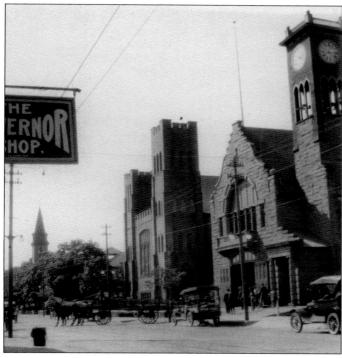

A team of horses backs the ladder truck into the City Hall fire garage in this 1923 photograph. The First Methodist Episcopal Church is to the left of City Hall. The Hancock Volunteer Fire Department operated out of City Hall from 1899 to 1997, when a new fire hall was opened. City Hall remains the home of the city administration to this day. (Joseph Meinardi family.)

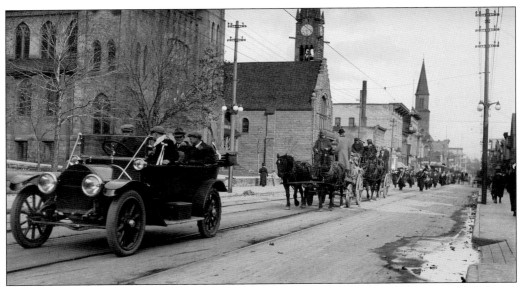

This October 12, 1912, parade is headed for Hancock's Driving Park and the annual Michigan College of Mines freshmen-versus-sophomores football game. It was then the main athletic event of the college year, with the players transported on horse-drawn drays. The lead car appears to carry seniors, who were instructed to wear hats, flowers, and ribbons and to carry canes. (Michigan Technological University Archives and Copper Country Historical Collections.)

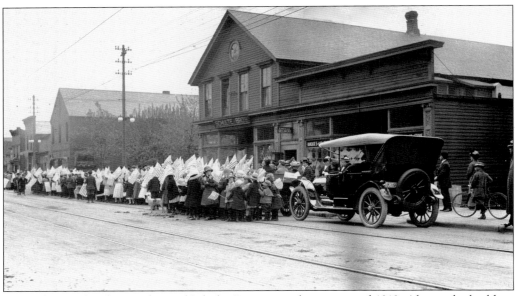

A parade crowd gathers in front of Schulte Bros. general store around 1912. Also in the building are Ethel M. Kinsman's millinery shop and Hancock's five-and-dime store. The next building to the left is Charles Gekas' confectionery shop, which is now home to a radio broadcasting company. (Michigan Technological University Archives and Copper Country Historical Collections.)

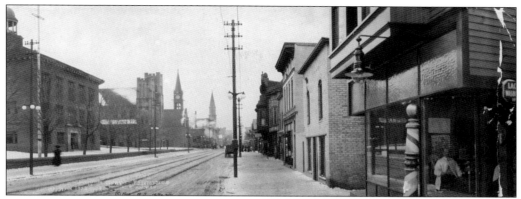

This 1910 view looks east from Quincy Street's 400 block. From left to right are the high school, Hancock Methodist Episcopal Church, and City Hall. At the far right is Max Brenner's barbershop. The building past Brenner's would soon be replaced by the Orpheum Theatre. City Hall was added to the National Register of Historic Places on June 1, 1981. (Library of Congress, LC-USZ62-130025.)

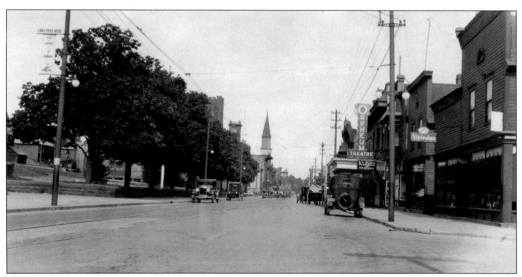

The Orpheum Theatre marquee is seen here around 1930. Originally a vaudeville theater before becoming a motion picture house, the Orpheum, later named the Pic Theatre, opened in 1911. It has recently been renovated into a pizzeria with a stage for concerts and other performances. The utility pole on the far left features a schedule sign for the Houghton County Traction Company's streetcar line. (Nancy Sanderson.)

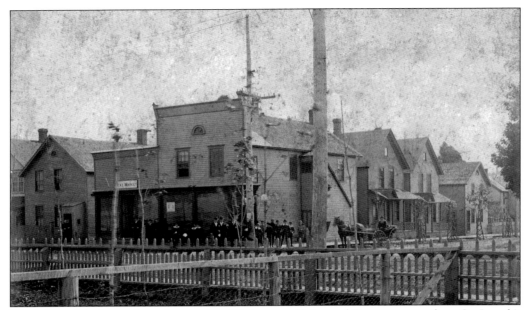

The Mason Block stood on the corner of Quincy and Mesnard Streets, across from St. Joseph's Catholic Church. Seen here around 1890, it contained a meat market, grocery, and bakery owned by Thomas D. and William H. Mason. The brothers were Civil War veterans from Wisconsin. None of the buildings seen in this image survive today. (Michigan Technological University Archives and Copper Country Historical Collections.)

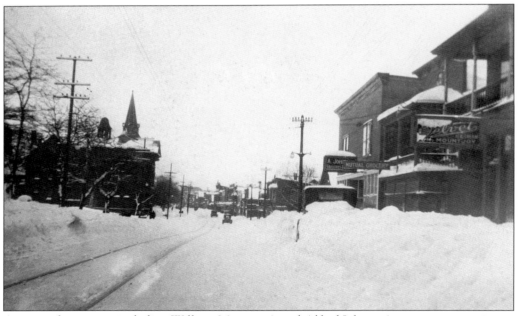

A series of groceries, including William Mountjoy's and Alfred Johnson's, are seen on a wintery Quincy Street in about 1930. Farther down on the right is electrical contractor Edward Cuff's storefront. On the left is St. Joseph's School. Today, the occupants of these grocery buildings include a dentist and a garden supply store. (Jack Deo-Superior View.)

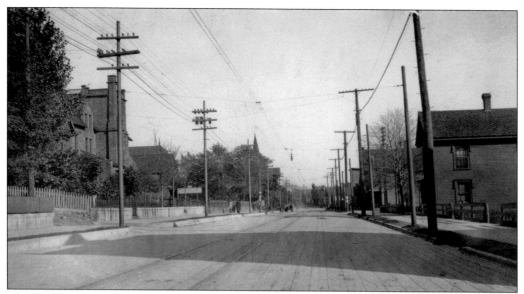

This early-1900s view looks east down Quincy Street from just west of Dacotah (now Dakota) Street. The large sandstone building on the left is Suomi College. (Nancy Sanderson.)

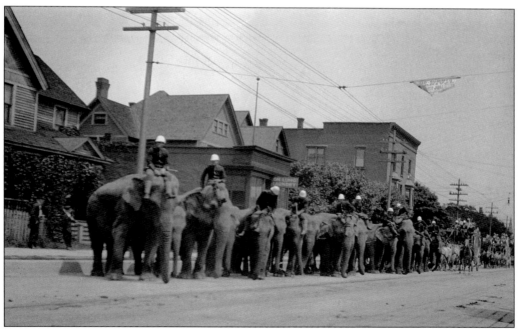

This is likely the Ringling Bros. Circus parade of July 11, 1912. The large building below and left of the banner is a longtime grocery store that recently closed. On Lung Laundry, seen behind the elephants, was one of multiple Chinese laundries in Hancock in the 1910s. (Michigan Technological University Archives and Copper Country Historical Collections.)

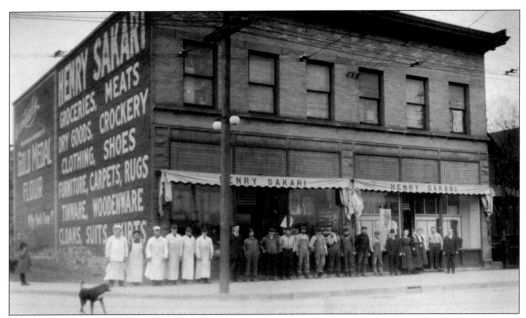

Henry Sakari peddled household goods prior to opening a small meat market. His success led to this larger store, opened around 1907 on the corner of Quincy Street and Railroad Avenue (now South Lincoln Drive), which offered meats, groceries, dry goods, clothing, and more. The building is now an apartment complex, appropriately named the Market Apartments. (Houghton County Historical Society.)

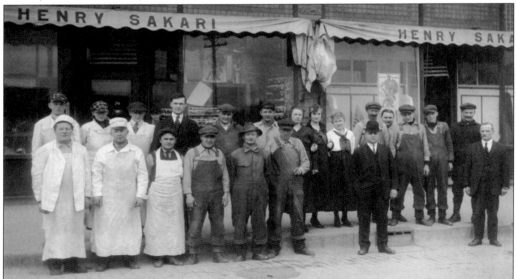

Employees and family members stand in front of Sakari's market around 1918. From left to right are (first row) Peter Juntti, Eino Matola, William Bredback, Richard Hanson, Edward Luusua, Oscar Karvonen, Henry Sakari, and unidentified; (second row) three unidentified workers, Walfrid Bousu, Carl Sakari, Peter Sakari, Ida Beck, Lillian Bousu, Martha Huovinen, ? Huovinen, Hjalmer Sakari, Edward Ahola, John Bousu, and unidentified. The person standing in the left background beside the door is unidentified. (Houghton County Historical Society.)

Five

CHURCHES AND SCHOOLS

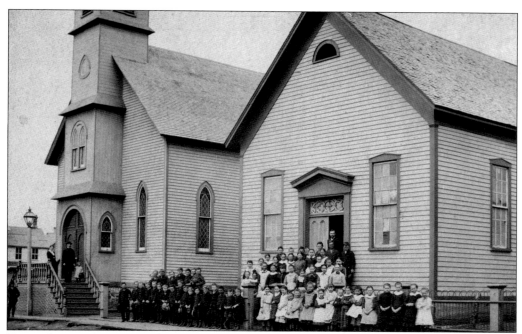

Hancock's new St. Peter and St. Paul's Evangelical Lutheran Church (left), built in 1881, stands next to its predecessor, built in 1867. The original church was converted to a school and remained so through 1917. The two buildings, at the corner of Hancock and Montezuma Streets, are now connected and are home to a housing resource center, the congregation having moved to Houghton in 2009. (Houghton County Historical Society.)

Construction of a united Christian church to serve several small denominations began at the corner of Hancock and Tezcuco Streets in 1861. Dissention over the type of services to be offered festered, and the Episcopalians resolved in October to move the church to Houghton. Before it crossed Portage Lake on scows, someone painted "Bound for Hell" on the side of the building, which became Houghton's Trinity Episcopal Church (right), seen here later in the 1860s. Hancock's First Congregational Church (far left, in the distance) was built on the original site in 1862. That same year, a letter to a local newspaper complained of its partiality shown to Houghton over Hancock. The letter stated, in part, "Our Episcopal church was a two-story pigstye until it was taken across the lake, where, by some miraculous power, it was suddenly transformed into a divine palace, where even kings might worship." The "divine palace" has since been replaced, but many feel that the newspaper retains the same bias to this day. (Houghton County Historical Society.)

The First Congregational Church was destroyed in the 1869 fire, and the congregation immediately planned to rebuild on the site. The basement of the new church was available for use later in the year, and the building seen here was officially dedicated in 1870. This church was also lost to fire on March 7, 1917. (Michigan Technological University Archives and Copper Country Historical Collections.)

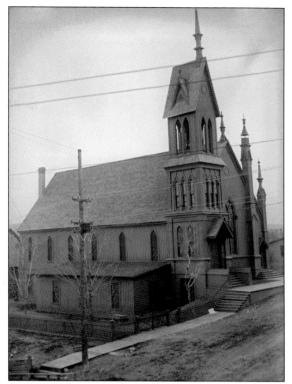

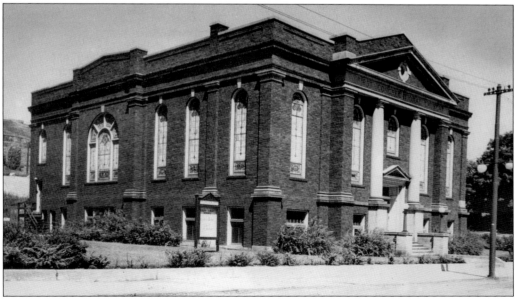

This First Congregational Church, pictured here around 1933, was dedicated in 1921. It was located at the end of Quincy Street, east of the Kerredge Theatre. Services were held at Germania Hall in the interim following the 1917 fire. The congregation merged with the First Presbyterian Church of Houghton in 1969, and this building was razed in the 1970s. The site is now a parking lot. (Houghton County Historical Society.)

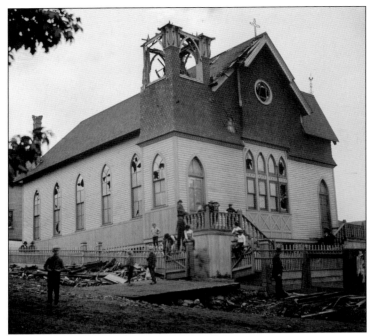

The Finnish Evangelical Lutheran Church is seen in the aftermath of the August 28, 1896, lightning strike, which killed assistant pastor and newly appointed Suomi College instructor Jooseppi Riippa. Riippa had just dismissed about 50 children because of the threatening weather. Erected in 1889, the church burned down on March 14, 1909. (Michigan Technological University Archives and Copper Country Historical Collections.)

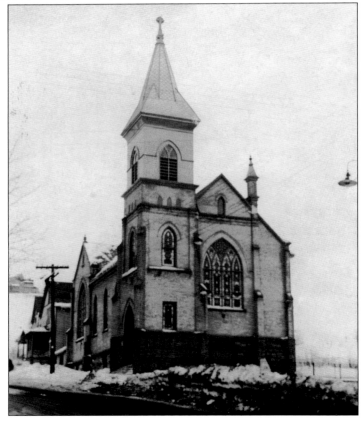

The foundation, including the 1889 cornerstone, remained following the 1909 fire, and the second Finnish Evangelical Lutheran Church, seen here, was dedicated on the site in 1910. It was renamed St. Matthew's Evangelical Lutheran Church in the 1950s, and the congregation merged to form Gloria Dei Lutheran Church in the 1960s. Glad Tidings Assembly of God later occupied this building, which is now a seasonal antiques store. (Jeff Thiel.)

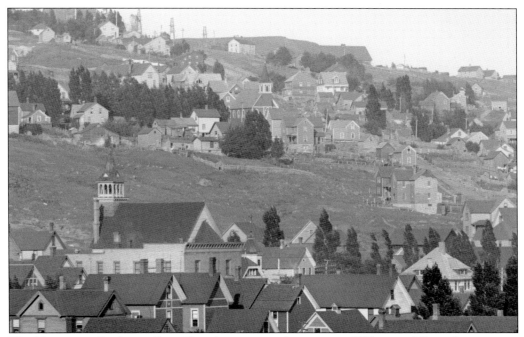

The Norwegian Lutheran Free Church is seen at the corner of White and Finn Streets, near the center of this c. 1906 photograph. The church was erected in the 1890s and ceased holding services in the 1930s. In 1941, the structure was offered to the First Lutheran Church of L'Anse, Michigan, whose congregation dismantled it and used the materials in the construction of their church building. (Library of Congress, LC-DIG-det-4a07015.)

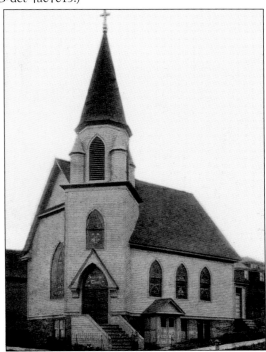

This early, undated view shows the Swedish Lutheran Church, on the corner of Railroad Avenue (now South Lincoln Drive) and Michigan Street. It was renamed Salem Lutheran Church, and the congregation later merged with St. Matthew's Evangelical Lutheran Church to form Gloria Dei Lutheran Church. The building, constructed around 1899, is now home to the Church of Christ and looks very much the same. (Nancy Sanderson-Keweenaw County Historical Society.)

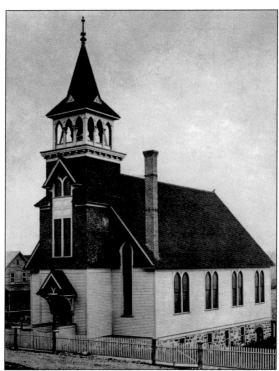

The Finnish Apostolic Lutheran Church, seen in this early, undated photograph, was designed by C. Archibald Pearce and built in about 1897. Located on Franklin Street, the church witnessed the growth and development of Suomi College all around it. This historic building burned down on December 26, 1990. Zion Lutheran Church, on Ingot Street, is now home to the congregation. (Zion Lutheran Church.)

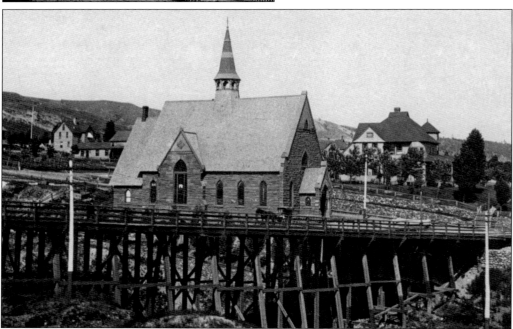

The Portage Lake Baptist Church was built at the corner of Front and West (now Dunstan) Streets in 1894. An elevated Front Street is seen in this early photograph, with East Hancock homes in the background. The remodeled church building is now a gas and service station. (Houghton County Historical Society.)

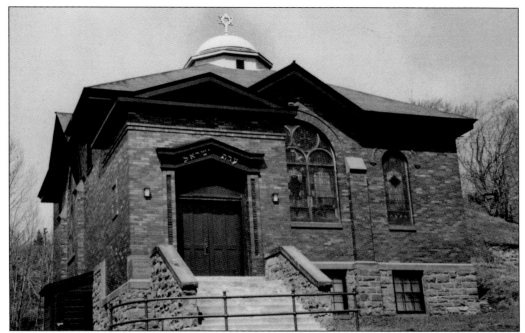

Temple Jacob was dedicated on September 1, 1912, making it the oldest Jewish house of worship in the Upper Peninsula. It is named for businessman and cofounder Jacob Gartner, who contributed generously to its construction. Situated just east of the bridge connecting Hancock to points south, it has been a Copper Country landmark for more than a century. (Michigan Technological University Archives and Copper Country Historical Collections.)

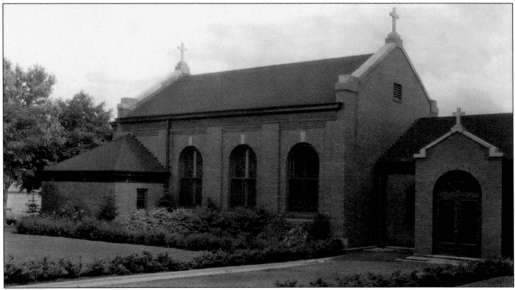

Seen here shortly after its 1929 construction, St. Joseph's Chapel was attached to the east end of St. Joseph's Hospital, on Water Street. Use of the small chapel diminished following the building of a new hospital facility in the 1950s, and the space was later utilized as a library. The chapel was demolished along with the old hospital in 1985. (Portage Health.)

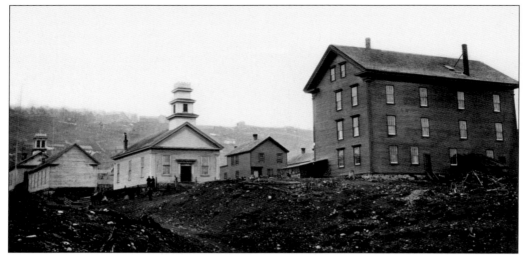

St. Anne's Catholic Church (left) and the Methodist Episcopal Church (third from left) each opened in 1861 and survived the fire of 1869. The latter's congregation moved from the corner of Hancock and Ravine Streets to a new Hancock Methodist Episcopal Church near City Hall on Quincy Street in 1903. Hancock's original Masonic Hall is at the far right of this c. 1870 photograph. (Houghton County Historical Society.)

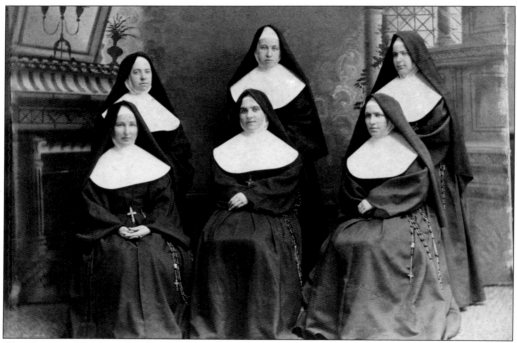

The Sisters of St. Joseph of Carondelet, St. Louis, Missouri, served in the parishes of St. Anne, St. Joseph, and St. Patrick; at St. Joseph's Hospital; and at St. Joseph's School of Nursing. The congregation was a blessed presence in Hancock for more than a century. Pictured here are the sisters on mission to St. Anne's in 1870–1871. (Sisters of St. Joseph of Carondelet, St. Louis Province Archives.)

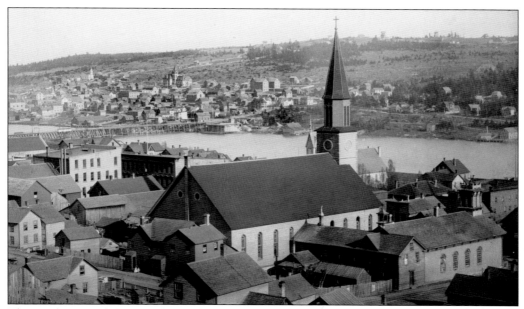

The newly erected St. Patrick's Catholic Church, on Quincy Street, dominates this view, seen around 1889. The interior of the church was completed during the winter of 1888–1889, and the building was dedicated on March 17, 1889. St. Anne's Church and rectory, seen immediately to the right of St. Patrick's, were demolished in the fall of 1889. (Michigan Technological University Archives and Copper Country Historical Collections.)

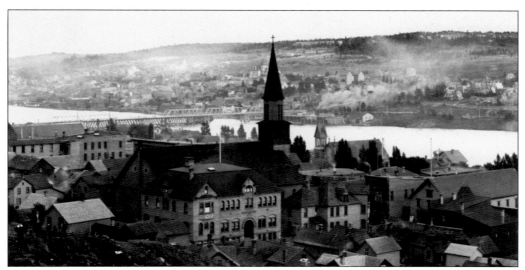

St. Patrick's Catholic Church continues to stand tall at the center of this 1890s photograph. Immediately to its right, St. Anne's has been replaced by a new rectory, which opened in 1891. Behind the rectory, with an entrance on Ravine Street, is St. Patrick's School, which opened in 1894. All of these buildings were destroyed by fire on March 6, 1937. (Michigan Technological University Archives and Copper Country Historical Collections.)

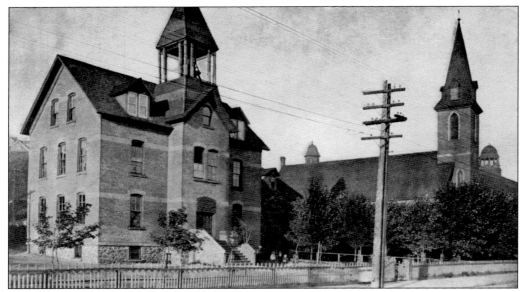

St. Joseph's School (left) and St. Joseph's Catholic Church are seen here around 1900. When the congregation grew far too large for St. Anne's and the already-started St. Patrick's, an agreement was reached to partition the parish. The Irish retained St. Anne's and completed the construction of St. Patrick's, while the Germans accepted $5,000 and, with the French, opened St. Joseph's on Quincy Street near Ryan Street in 1885. (Houghton County Historical Society.)

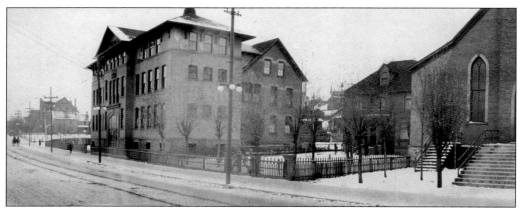

A substantially altered St. Joseph's School, complete with a large addition, is shown here in 1910. The convent is attached to the rear of the school. The smaller building to the right is the rectory, built in 1895. The church is now Finlandia University's Finnish American Heritage Center, the rectory is Finlandia's bookstore, and the site of the school and convent is a parking lot. (Library of Congress, LC-USZ62-130025.)

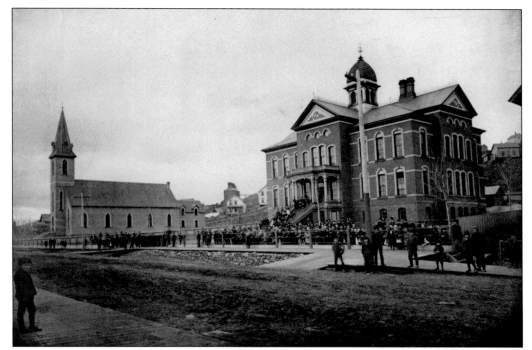

Hancock High School (right) was constructed on Quincy Street in 1875. Seen here around 1886, it served public school students in all grades until the Central Primary School was added in 1894. St. Joseph's Catholic Church is on the left, and the Hancock Mine shaft-rockhouse is visible in the distance between the church and the school. (Author's collection.)

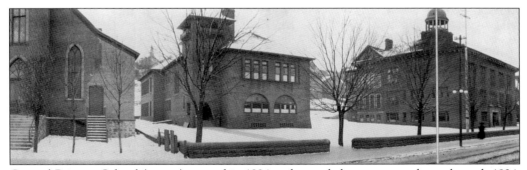

Central Primary School (center) opened in 1894 and served elementary students through 1924. The building was later used by several organizations, including the American Legion, before being demolished in about 1962. The front of St. Joseph's Catholic Church (left) and the expanded Hancock High School (right) are also seen in this 1910 image. (Library of Congress, LC-USZ62-130025.)

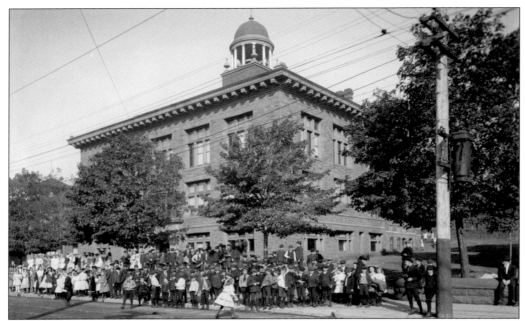

Hancock High School, seen here around 1905, was remodeled and expanded with a sandstone front in 1900. The structure burned down on July 25, 1922. At least three citizens—Natalie Elwood, Paul Ruppe, and Dr. Peter Steinback—are known to have entered the blazing building to retrieve school records not stored in the vault. The adjacent First Methodist Episcopal Church sustained minor damage. (Library of Congress, LC-DIG-det-4a13088.)

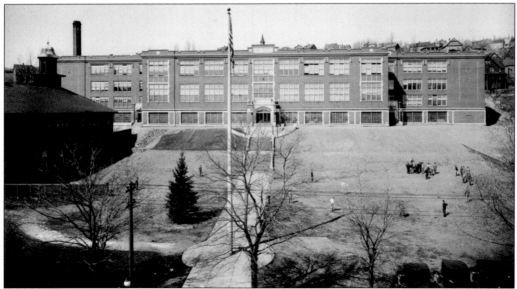

A new high school was erected in 1923 behind the ruins of the former school, and students from the Central Primary School were transferred to the new building in 1924. The structure was utilized by the public school district through 2009 and is now owned by Finlandia University. Here, boys are playing baseball on the front lawn in about 1925. (Michigan Technological University Archives and Copper Country Historical Collections.)

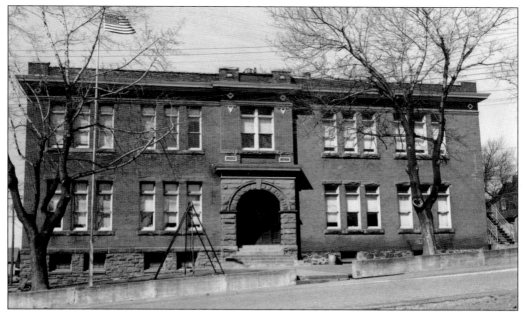

The Edward Ryan School opened on Michigan Street in 1897 and served as an elementary school until 1989. Edward Ryan was a prominent businessman and community leader. Dubbed the "Merchant Prince of the Copper Country," he was a member of the school board for nearly three decades. Known as the Ryan Center today, the building contains a child day care center and preschool. (Hancock Public Schools.)

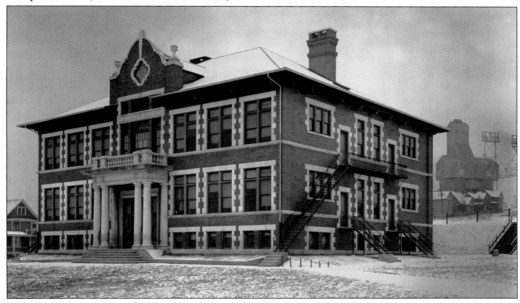

The E.L. Wright School opened on the corner of Oak (now North Lincoln Drive) and Elevation Streets in 1910 and served as an elementary school until 1989. A multipurpose facility today, it is seen here in 1915 with the Hancock Mine No. 2 shaft-rockhouse in the background. A well-known businessman, Wright served on the school board for more than 20 years. (Michigan Technological University Archives and Copper Country Historical Collections.)

This undated view shows the Franklin Street School past its prime. Likely constructed in about 1863, it survived the 1869 fire and served Hancock children until 1875. It was also the site of early German Lutheran services before St. Peter and St. Paul's Evangelical Lutheran Church opened in 1867. The building was remodeled in the 1870s, resulting in this design with a single front door. (Joseph Meinardi family.)

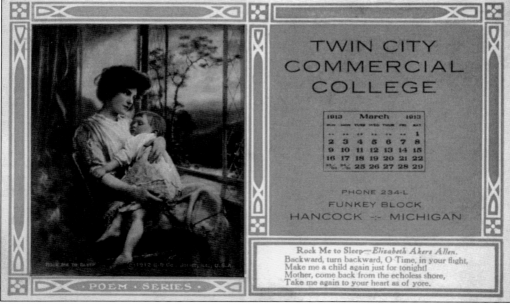

The Twin City Commercial College occupied multiple downtown locations, including the Funkey Block, the First National Bank building, and the Epstein Block, from the early 1910s into the 1930s. The college advertised teaching the "Science of Business," including courses in bookkeeping and stenography. (Nancy Sanderson-Keweenaw County Historical Society.)

Six

BRIDGES AND PORTAGE LAKE

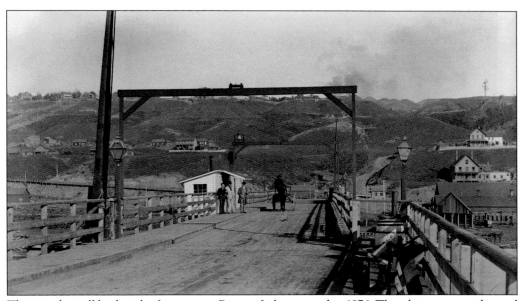

This wooden toll bridge, the first to span Portage Lake, opened in 1876. The white structure housed the engine and machinery needed to operate the swing section, which opened to allow marine traffic to pass. This view looks north toward Hancock in about 1880. The bridge emptied out onto Front Street, seen to the left heading to and from town. (Michigan Technological University Archives and Copper Country Historical Collections.)

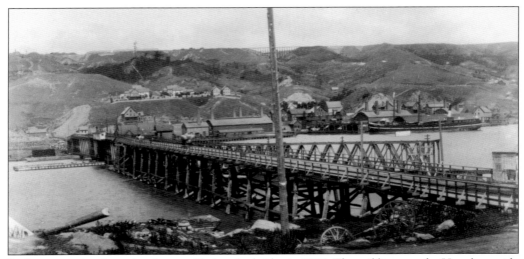

Rail service, via a lower level, was added to the bridge in 1886. The rail lines on the Houghton side appear to the right of the original bridge in this photograph from around 1890. The tracks pass underneath the main bridge and exit to the left on the Hancock side. (Michigan Technological University Archives and Copper Country Historical Collections.)

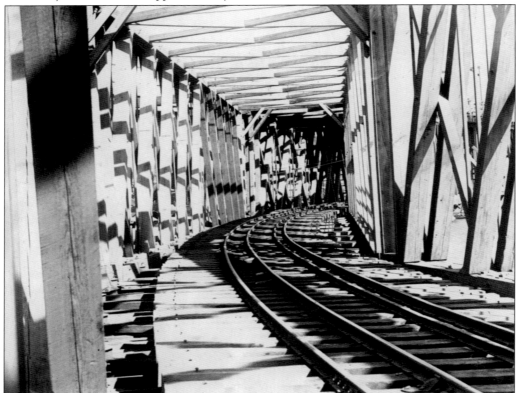

This view shows the rail lines running on the lower level of the bridge. Note that the tracks are mixed gauge to accommodate multiple railroad companies. (Michigan Technological University Archives and Copper Country Historical Collections.)

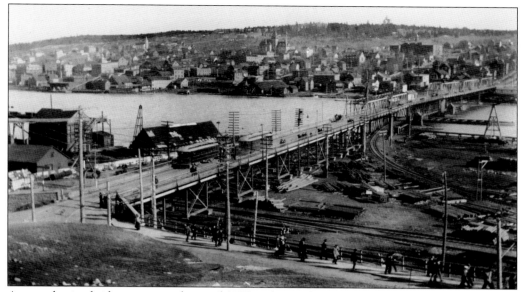

A second swing bridge was erected around 1895, replacing the original wooden structure. The newer bridge, seen in the early 1900s, was made of steel except for the swing section, which remained wooden. Pedestrians are walking toward Hancock on Front Street in this image. Houghton is seen on the south side of Portage Lake. (Michigan Technological University Archives and Copper Country Historical Collections.)

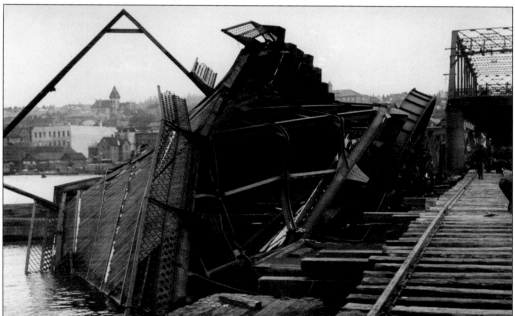

On April 15, 1905, the steamer *Northern Wave* struck the swing section of the bridge and toppled it onto its side. This photograph, taken a few days later, shows temporary rail tracks being installed in the gap. The south side was cleared and opened to marine navigation by April 25, but the bridge was not fully repaired until the following spring. (Michigan Technological University Archives and Copper Country Historical Collections.)

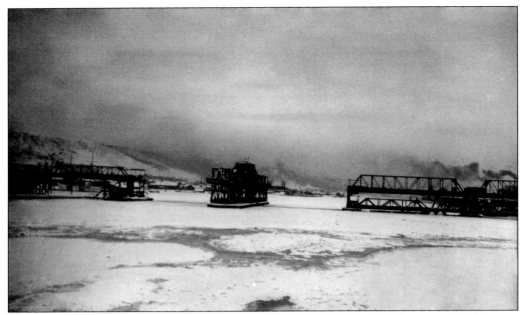

The new, post-1905 swing section is open for passage, as seen from an approaching vessel. Pedestrians and a streetcar await their turn on the bridge. It was common for local youth to attempt to be on the swing portion of the bridge while it was in motion. (Michigan Technological University Archives and Copper Country Historical Collections.)

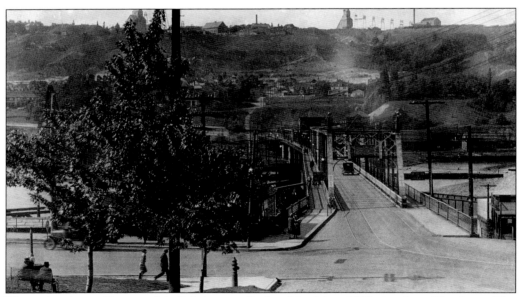

The pedestrian walkway and its lighting are displayed in this c. 1920 view from Houghton. The speed limit on the bridge at this time was 15 miles per hour. Some East Hancock homes are seen on the hillside, and the Quincy Mine No. 2 shaft-rockhouse is at the top of the image, directly above the bridge. (Bill Schoos.)

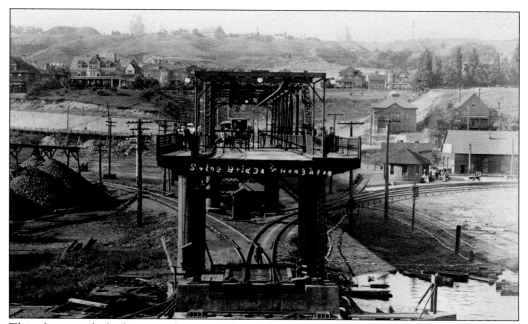

This photograph, looking north toward Hancock around 1913, was likely taken from the open swing section of the bridge. A young man stands on the railroad tracks below, which split to the east and west upon crossing the lake. Immediately to the right of the bridge and behind the rail depot is Temple Jacob. (The David V. Tinder Collection of Michigan Photography, Clements Library, University of Michigan.)

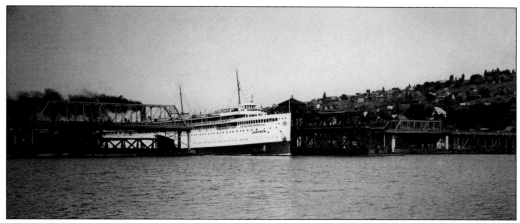

The Great Lakes Transit Corporation's SS *Juniata* steams through Portage Lake in the 1930s. The steel swing bridge was replaced by a modern lift bridge immediately to the west. The lift bridge opened in late 1959, was dedicated in 1960, and is still in service today. (Nancy Sanderson-Keweenaw County Historical Society.)

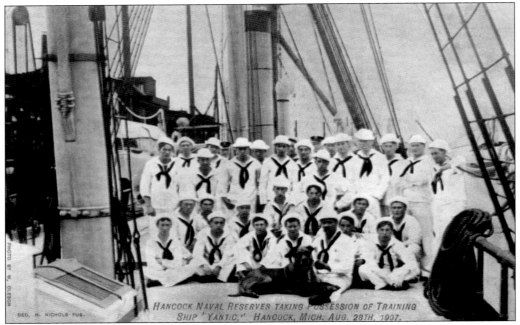

The USS *Yantic* was loaned by the US Navy to the Hancock Naval Reserve for use as a training vessel from 1907 to 1917. The reserve members were drilled on everything from boat handling, navigation, and signaling to beach assaults. The *Yantic* was returned to the US Navy upon the country's entry into World War I. (Bill Schoos.)

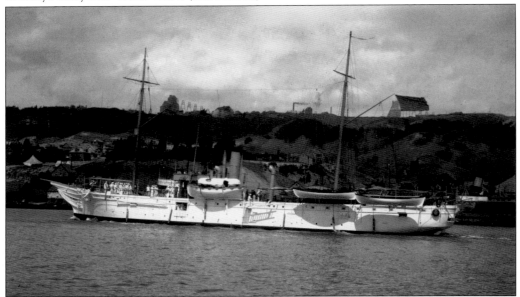

Built in 1864, the USS *Yantic* was originally a Civil War gunboat. The ship was rumored to have been designed as Pres. Abraham Lincoln's private yacht but was instead pressed into military service. Seen here on Portage Lake in 1911, the *Yantic* sank in 1929 following the natural deterioration of its wooden hull. (Michigan Technological University Archives and Copper Country Historical Collections.)

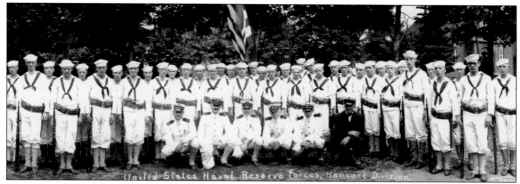

Members of the US Naval Reserve Forces, Hancock Division, are pictured in Montezuma Park in 1924. St. Peter and St. Paul's Evangelical Lutheran Church is in the background on the right. The Hancock Naval Reserve saw members serve on active duty in both World Wars I and II. (American Legion Alfred Erickson Post No. 186.)

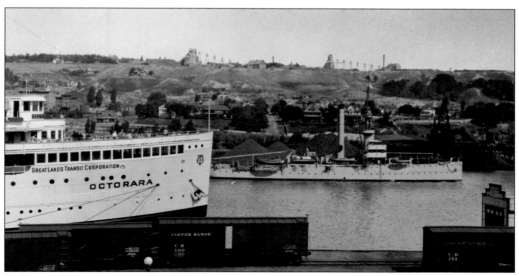

A Hancock Naval Reserve dreadnought is cruising Portage Lake in this 1930 photograph. The SS *Octorara*, sister ship of the *Juniata*, is docked on the Houghton side. The image offers a panoramic view of East Hancock, from the Scott Hotel (far left) to Temple Jacob (far right). In the middle is the aptly named Center Street. (Michigan Technological University Archives and Copper Country Historical Collections.)

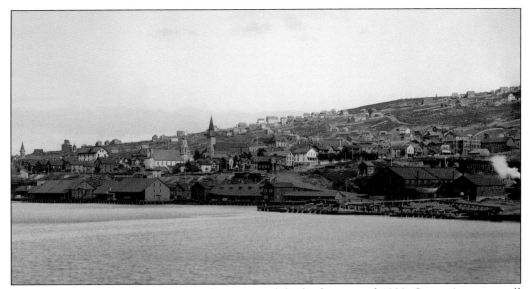

This view shows the Hancock waterfront west of the bridge around 1889. Quincy's stamp mill is at the lower right. The company was about to move their stamping operation six miles east to Torch Lake. The road curving from the mill toward town is Reservation Street. (Michigan Technological University Archives and Copper Country Historical Collections.)

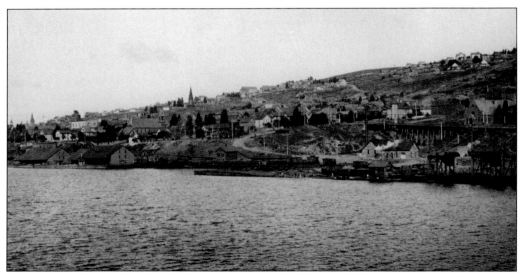

Quincy's pump house has replaced their stamp mill in this c. 1898 photograph. The pump sent water from Portage Lake up to the mine sites on Quincy Hill. The Portage Lake Baptist Church (far right) and the Peter Ruppe house (seen directly above the pump house) were also new additions to the landscape in the 1890s. (Houghton County Historical Society.)

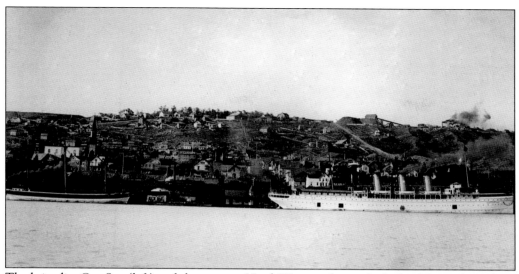

The brigadier *Our Son* (left) and the steamer *North West* are shown docked in Hancock in about 1896. Immediately to the left of the *North West* is the Mineral Range Railroad passenger depot, at the base of Tezcuco Street. It was later moved several blocks west and up the hill from the waterfront and dubbed Lake View Station. (Michigan Technological University Archives and Copper Country Historical Collections.)

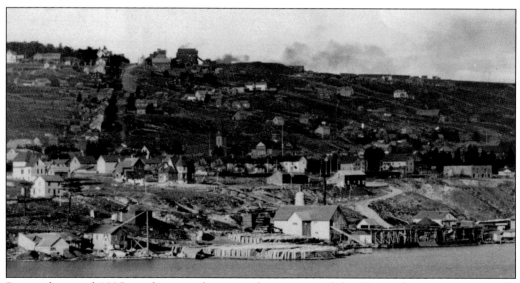

Pictured around 1895 on the waterfront are the remains of the Hancock Mine's stamp mill. The road on the left going up Quincy Hill is Ryan Street. The square-shaped building under construction on the far right is Edward Lieblein's wholesale grocery store. The building is now home to an architectural and engineering firm. (Houghton County Historical Society.)

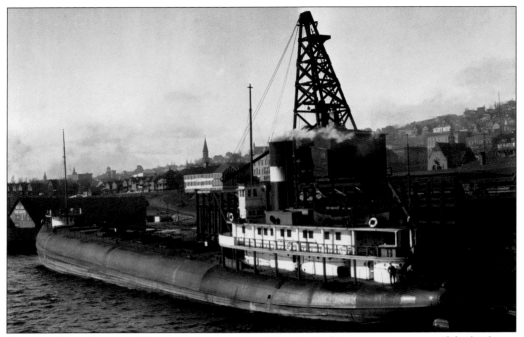

The whaleback *Progress of Fairport* is docked at the People's Fuel Company just west of the bridge in the 1910s. A coal derrick towers over the waterfront. To the right stands the Portage Lake Baptist Church, with the Scott Hotel and the Kerredge Theatre behind it. (Michigan Technological University Archives and Copper Country Historical Collections.)

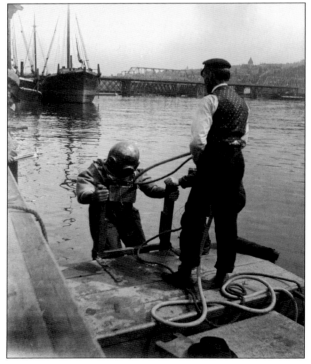

Although primarily used as a maritime transportation corridor, Portage Lake has been host to many other activities over the years. Here, two men assist a diver entering the water around 1896 while several others look on. The new steel swing bridge is seen in the background. (Jack Deo-Superior View.)

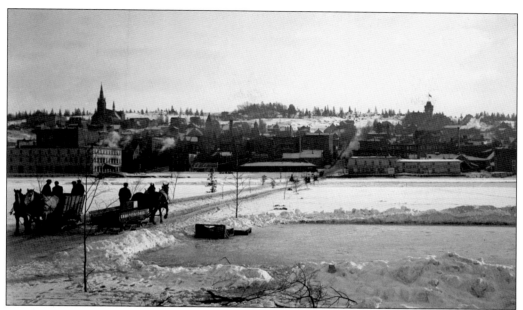

Two horse teams pass each other on a Portage Lake ice road east of the bridge in this undated photograph. The ice road continues onto Huron Street in Houghton. Note the area cleared for ice hockey in the foreground. (Michigan Technological University Archives and Copper Country Historical Collections.)

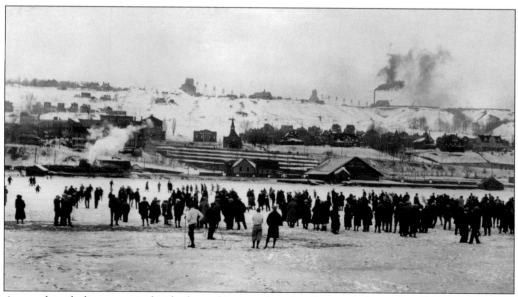

A crowd, including some individuals on skis, is gathered at Portage Lake in this 1920s view. At the center on the waterfront is Quincy's pump house. Behind it are the Portage Lake Baptist Church and the First Congregational Church (left). To the right of the pump house on the lakeshore is the Great Lakes Transit Corporation. (Houghton County Historical Society.)

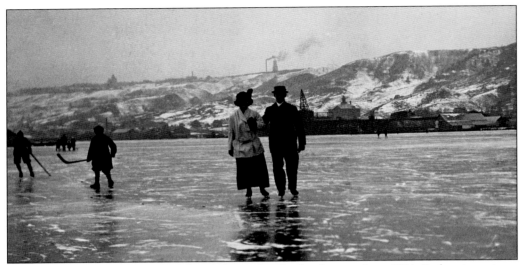

A couple enjoys a skate on the lake while youths play hockey in about 1914. Embracing winter activities is an important part of living in the Copper Country. (Michigan Technological University Archives and Copper Country Historical Collections.)

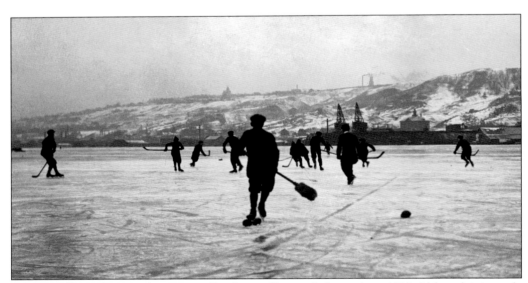

A group of boys plays a pickup game of hockey on Portage Lake in about 1914. Although it is rarely played on the lake today, Copper Country residents are still passionate about hockey. There are several rinks, both indoor and outdoor, in the Hancock area, and there are leagues for all ages. (Michigan Technological University Archives and Copper Country Historical Collections.)

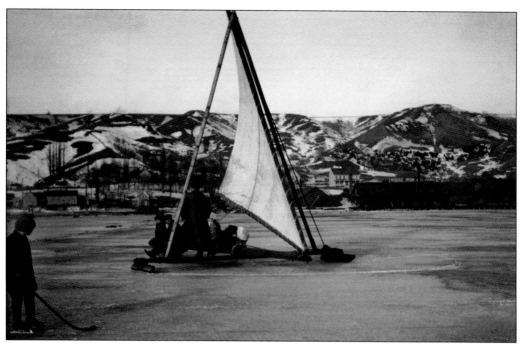

Iceboating is another way to take advantage of the frozen lake. This rig is seen east of the bridge around 1912, with the Hodge Iron Company (right) on the Ripley waterfront in the background. (Michigan Technological University Archives and Copper Country Historical Collections.)

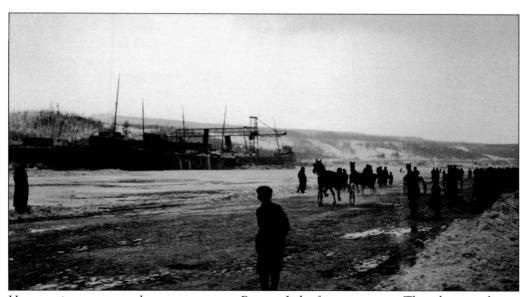

Horse racing was a regular occurrence on Portage Lake for many years. This photograph was taken around 1911, near the end of the sport's popularity. Hancock's Driving Park was the site of countless races in the non-winter months. (Michigan Technological University Archives and Copper Country Historical Collections.)

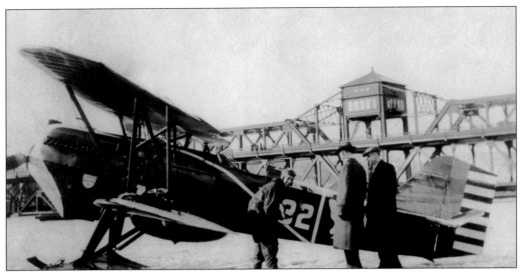

Aviator Caesar Lucchesi (left) built a runway on stamp sand left over from the Isle Royal Mine's copper-stamping operation on Portage Lake. Later, he was instrumental in determining the location of the Houghton County Airport, which was placed about five miles north of Hancock. Lucchesi is seen here with one of his airplanes on the frozen lake, with the bridge in the background, around 1930. (Ken Linna.)

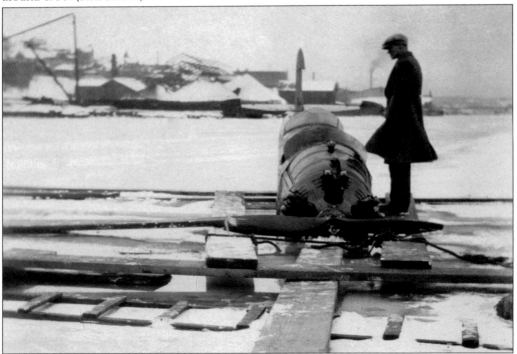

Activities on frozen lakes are not without mishaps. This airplane found itself on thin ice around 1931. Most residents likely cannot recall such a sight on Portage Lake, but today, it is not uncommon for a snowmobile to fall through thin ice. (Michigan Technological University Archives and Copper Country Historical Collections.)

Seven

MINING ACTIVITY

The Quincy Mining Company had a double-tracked tramway, roughly 2,200 feet in length, running from Quincy Hill down to their stamp mill on Portage Lake. This view shows the tramway around 1885. Note the man walking down the incline in the middle of the image. The building on the left is the back portion of Hancock's first fire hall, at Quincy and Reservation Streets. (Author's collection.)

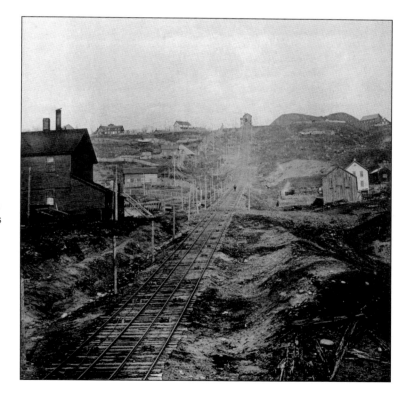

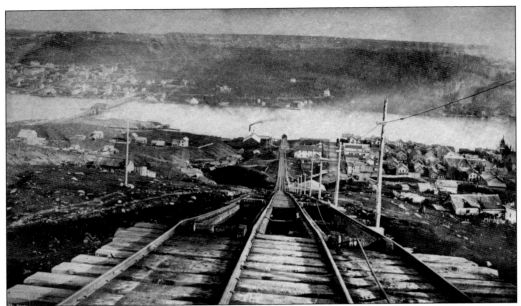

The best way to appreciate the tramway is arguably from the top. This view from around 1880 looks down the line, with the stamp mill on the left and the fire hall on the right. To the right of the fire hall is Reservation Street. At the far right of the image is the First Congregational Church. (Frank Klepetko Michigan Mining Cyanotype Album, Archives Center, National Museum of American History, Smithsonian Institution.)

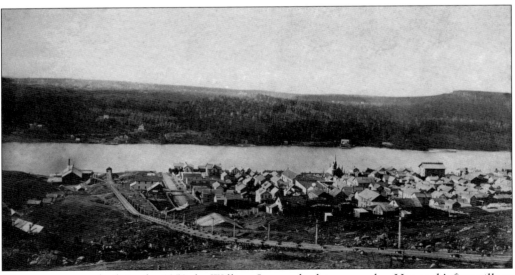

The tramway was built in the 1850s by William Lapp, who later served as Hancock's first village clerk. In addition to the vertical run, it extended to multiple shaft houses on Quincy Hill, for a total length of about 3,500 feet. The large building near the far right of this view is the original Masonic Hall. (Frank Klepetko Michigan Mining Cyanotype Album, Archives Center, National Museum of American History, Smithsonian Institution.)

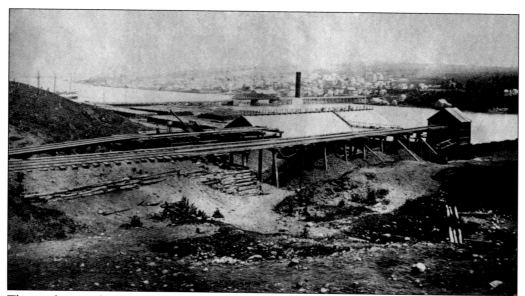

The southern end of the Quincy tramway is shown here around 1880. The small structure at the end of the line on the right contained the main ore dump, which fed directly to the stamps in the mill. Two men stand near a car being tipped for unloading on the other line. (Frank Klepetko Michigan Mining Cyanotype Album, Archives Center, National Museum of American History, Smithsonian Institution.)

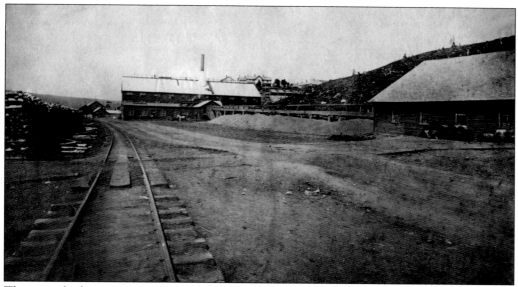

This view looks west toward Quincy's stamp mill in about 1880. The building on the right, connected to the mill by an elevated launder, was a tailings washhouse. It contained washing equipment and a set of burr stones used to regrind some of the waste rock from the mill. (Frank Klepetko Michigan Mining Cyanotype Album, Archives Center, National Museum of American History, Smithsonian Institution.)

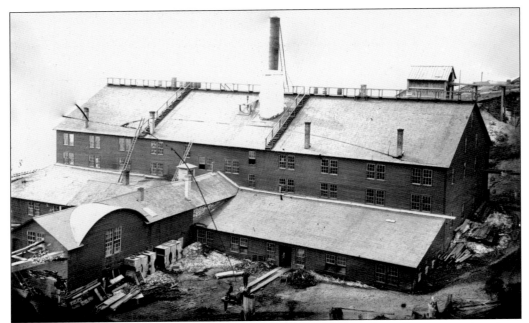

Quincy's stamp mill is seen up close in about 1880. At this time, the mill was stamping about 100,000 tons of rock and producing six million pounds of copper annually. Construction of the mill began in approximately 1858. The facility went into operation in March 1860 and was dismantled in 1893. (Michigan Technological University Archives and Copper Country Historical Collections.)

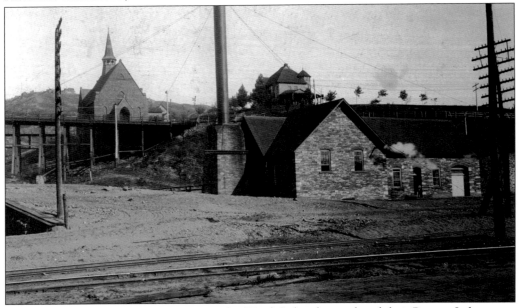

After Quincy's stamping operations moved to Torch Lake, they replaced their Portage Lake stamp mill with this pump house, which sent water from the lake up to the mine sites. Seen in the background are the Portage Lake Baptist Church (left) and the East Hancock home of Charles D. Hanchette. (Houghton County Historical Society.)

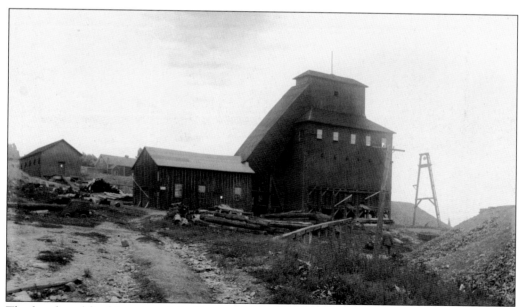

The Hancock Copper Mining Company, organized by Edward Ryan in 1879, was the third incarnation of the Hancock Mine. The original company began in 1859, and the second, known as the Sumner Mining Company, began in 1873. Each worked the Hancock amygdaloidal bed with limited success. Ryan's venture closed down in 1885, and the property remained dormant for the next 20 years. (Houghton County Historical Society.)

The fourth and final iteration of the Hancock Mine, the Hancock Consolidated Mining Company, was incorporated in 1906. Pictured here is the shaft-rockhouse above the original shaft in about 1915. It was then known as Hancock Mine No. 1. This area is the heart of Finlandia University's campus today. (National Park Service, Keweenaw National Historical Park, Myrno Petermann Glass Plate No. 373.)

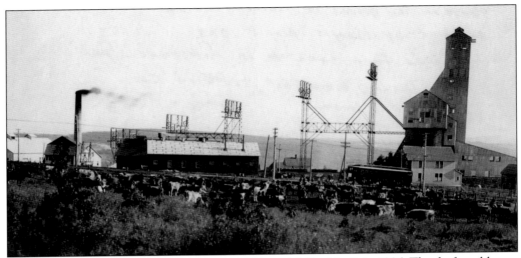

The company began working a new location, Hancock Mine No. 2, in 1906. The shaft-rockhouse was west of Elevation Street and south of Ingot Street. The residential house in the foreground still stands at that intersection. The majority of the surface buildings were east of Elevation Street. Here, a streetcar is traveling up Ingot Street on its way to Calumet. (Michigan Technological University Archives and Copper Country Historical Collections.)

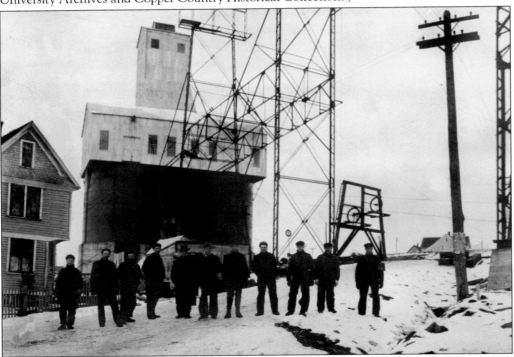

The Hancock Mine No. 2 shaft-rockhouse stood 128 feet high, with a working floor 60 feet above the ground. The steel structure rested on concrete abutments that were 14 feet high and 35 feet in diameter. Each of the two rock bins had a capacity of 1,000 tons. The company ceased operations in 1920, and this giant marvel was torn down around 1938. (Houghton County Historical Society.)

Eight

SUOMI COLLEGE AND FINNISH AMERICAN PUBLISHING

Amerikan Suomalainen Lehti, published in Hancock in 1876 by A.J. Muikku, was the first Finnish-language newspaper in the United States. The Copper Country soon became a hub of Finnish American publishing, including Hancock's *Sankarin Maine*. It was operated by Matti Fred and followed his *Swen Tuuwa*, which was published in Houghton. (Finlandia University's Finnish American Heritage Center and Historical Archive.)

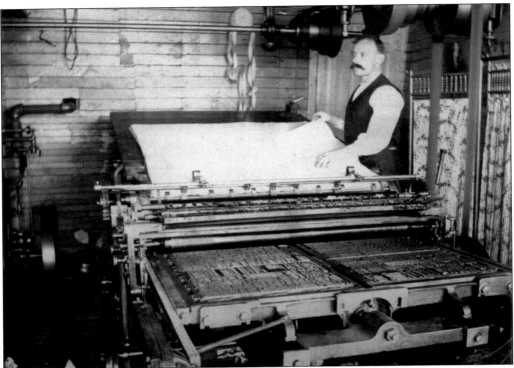

Victor Burman is shown printing his newspaper, *Amerikan Suomalainen*, around 1898. Burman published multiple Finnish titles in both the Copper Country and in Chicago during the 1890s. (Finlandia University's Finnish American Heritage Center and Historical Archive.)

Hancock's Finnish Evangelical Lutheran Church was erected on Reservation Street in 1889. In this early view, people are walking on the old Quincy tramway, and cows are in front of the church. Near the end of 1889, Rev. J.K. Nikander and other Church of Finland pastors formed the Finnish Evangelical Lutheran Church of America, also known as the Suomi Synod. (Jack Deo-Superior View.)

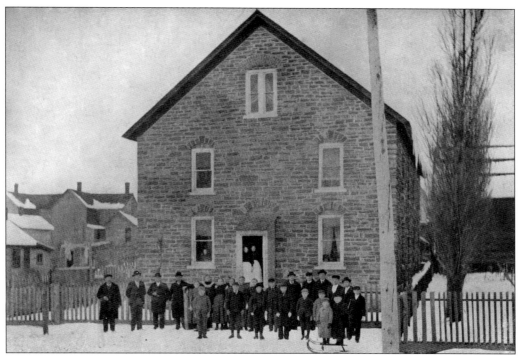

Nikander was named the first president of the synod in 1890, and plans began to found an *opisto*, an institution of higher learning. Suomi College and Theological Seminary opened in September 1896 in the rented quarters in West Hancock shown here. Classes were held on the first floor, while the second floor housed the president, the business manager/dean, and resident students. (Finlandia University's Finnish American Heritage Center and Historical Archive.)

Many Hancock residents remember this bathhouse operated by the Maki family on the corner of Quincy and Michigan Streets. It is shown here just prior to its demolition in 1970, generations after it was the original home of Suomi College. The college officially changed its name to Finlandia University in 2000. (Michigan Technological University Archives and Copper Country Historical Collections.)

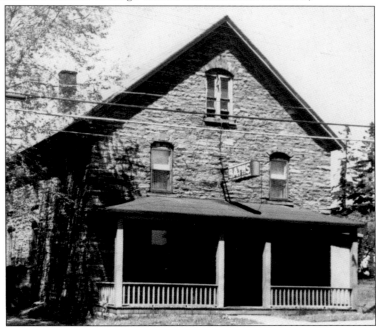

Desiring a building of its own, Suomi College acquired three lots on Quincy Street closer to the heart of town. Local architect C. Archibald Pearce was hired to design a new hall. The site work shown here was probably done in the fall of 1898. (Finlandia University's Finnish American Heritage Center and Historical Archive.)

The May 30, 1899, cornerstone-laying ceremony became quite an event, with people traveling from near and far to attend. The building was to be "an institution of higher education for Finnish American youth in the spirit of Evangelical Lutheranism." Village president A.J. Scott stated that "Hancock has got the Finnish theological college in which it is well pleased." (Finlandia University's Finnish American Heritage Center and Historical Archive.)

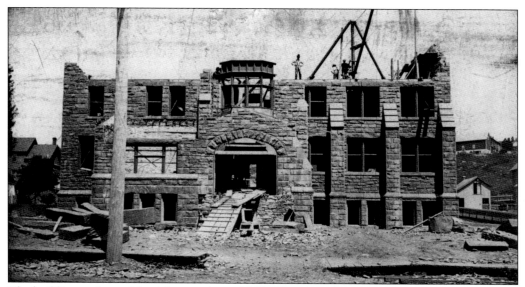

The building took roughly eight months and $40,000 to complete. It is constructed of Jacobsville sandstone quarried at the Portage Entry of the Keweenaw Waterway and transported by barge to Hancock. The structure was officially dedicated on January 21, 1900, and the staff and students moved in later that day. (Finlandia University's Finnish American Heritage Center and Historical Archive.)

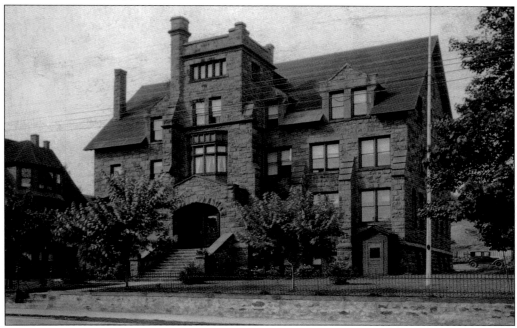

Old Main, as the building is affectionately known, was designated a Michigan State Historic Site on February 12, 1959, and added to the National Register of Historic Places on January 13, 1972. Shown in the 1920s, it continues to serve Finlandia University today, housing administrative offices such as those for admissions and financial aid. (Finlandia University's Finnish American Heritage Center and Historical Archive.)

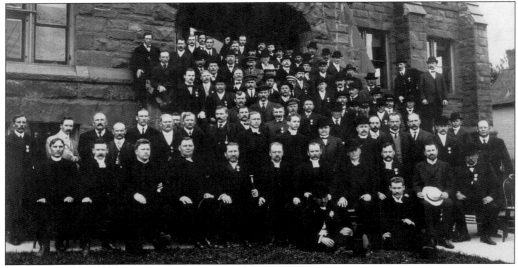

Leaders of the Suomi Synod met in Hancock in 1906. Rev. J.K. Nikander, president of both the school and the synod, is seated on a chair in the front row, fourth from right (wearing hat). After six decades in Hancock, the Theological Seminary separated from Suomi College on July 1, 1958, and affiliated with the Chicago Lutheran Seminary of Maywood, Illinois. (Finlandia University's Finnish American Heritage Center and Historical Archive.)

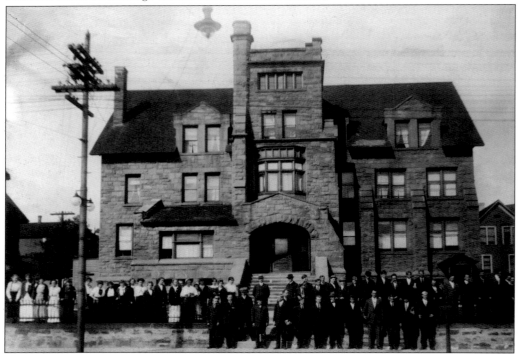

Students and faculty pose in front of Old Main in 1914. The Suomi Synod merged into the Lutheran Church in America (LCA) in 1962, which merged into the Evangelical Lutheran Church in America (ELCA) in 1988. The ELCA is the largest Lutheran denomination in the United States. (Finlandia University's Finnish American Heritage Center and Historical Archive.)

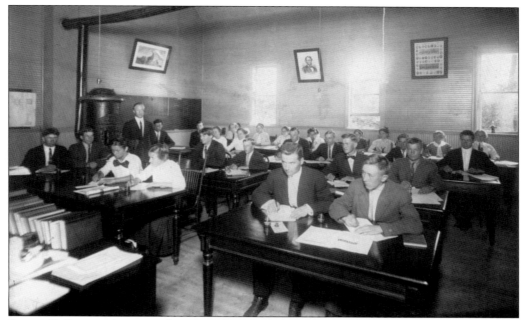

Suomi College students are shown in class in 1913. Finlandia University is now a liberal arts school offering associate and baccalaureate degrees in arts and sciences, business, fine art and design, and health sciences. (Finlandia University's Finnish American Heritage Center and Historical Archive.)

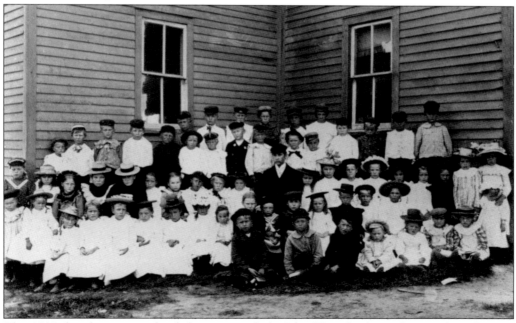

This 1900 church summer school class was taught by John Wargelin (center), a member of Suomi College's inaugural class who later graduated from the seminary. Reverend Wargelin twice served as president of the college and, in 1950, became the first president of the synod who was fluent in English. (Finlandia University's Finnish American Heritage Center and Historical Archive.)

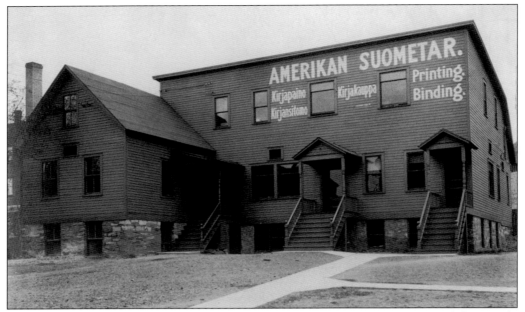

The Finnish Lutheran Book Concern opened behind Old Main in 1900. It printed the synod's newspaper, *Amerikan Suometar*, as well as other church and nonchurch material. The business moved from its campus location to Franklin Street in about 1965. Now known as Book Concern Printers, it remains the Copper Country's premier printing house. (Finlandia University's Finnish American Heritage Center and Historical Archive.)

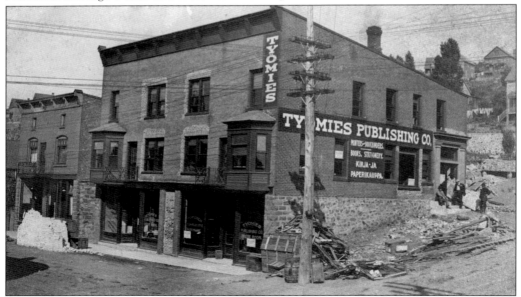

The Työmies Publishing Company arrived in Hancock in 1904 from Worcester, Massachusetts, and eventually occupied the corner of Tezcuco and Franklin Streets. Operated by the Työmies Society, it produced multiple publications, the most notable being *Työmies*, a Finnish-language newspaper that denounced American capitalism and advocated socialism and labor unions. (Nancy Sanderson-Keweenaw County Historical Society.)

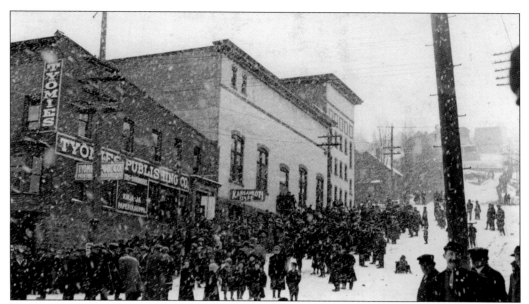

During the Copper Miners' Strike of 1913–1914, Kansankoti Hall (second from left) was a meeting place for both strike leaders and striking miners. The Western Federation of Miners' union newspaper, *Miners' Bulletin*, was printed in the Työmies building. Poststrike arrests of editors and advertising boycotts prompted *Työmies* to relocate to Superior, Wisconsin, in 1914. (Michigan Technological University Archives and Copper Country Historical Collections.)

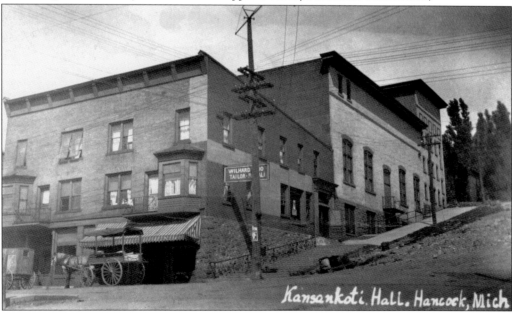

By 1915, tailor Wilhard Aho's sign hung at the corner, and all evidence of the Työmies Publishing Company had been removed. The monthly *Finnish American Reporter*, founded by the Työmies Society in Superior, Wisconsin, in 1986, moved to Hancock in 1999. A forum for the Finnish American community with no political or religious affiliation, it is published at Finlandia University. (Finlandia University's Finnish American Heritage Center and Historical Archive.)

A modest enrollment did not deter Suomi College from having a football team in 1907. Pictured from left to right are (first row) C. Sillberg, J. Wilamo, and A. Leppi; (second row) V. Lepisto, J. Keranen, E. Wesala, A. Kivari, and A. Heikkila; (third row) V.E. Lauri, J. Peterson, W. Luttio, and J. Salmu. Finlandia is planning to reintroduce football as a varsity sport in 2015. The university currently competes at the NCAA Division III level in baseball, basketball, cross-country, golf, hockey, soccer, softball, and volleyball. Hancock's connection to Finland is not limited to education, publishing, and religion. Though not the first to populate the area, the Finns have largely remained, and Hancock is the hub of Finnish culture in the United States today. Many street signs in the core downtown district are written in both English and Finnish. Hancock has an active Finnish Theme Committee, annually celebrates the midwinter festival Heikinpäivä, and has maintained a sister-city relationship with Porvoo, Finland, since 1990. (Jack Deo-Superior View.)

Nine

AROUND TOWN

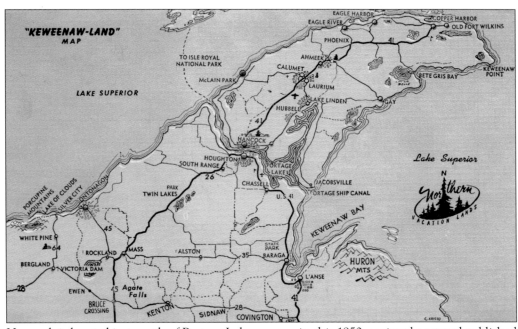

Hancock is located just north of Portage Lake, as seen in this 1950s regional postcard published by the Office Shop in Calumet. In addition to its native copper, the "Keweenaw-Land" is known for its rugged, natural beauty. (Author's collection.)

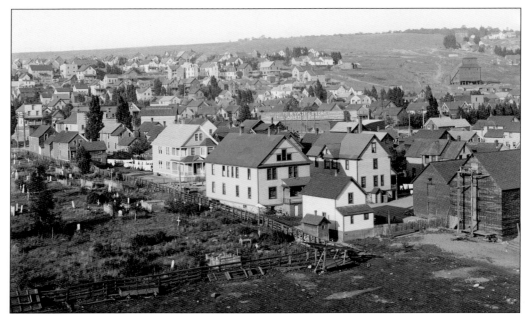

This is the first in a series of three images taken from atop St. Joseph's Hospital around 1905. The Catholic cemetery, now the site of Church of the Resurrection, is located at the lower left. The Hancock Mine shaft-rockhouse stands alone near the upper right, and many West Hancock homes are seen throughout. (Library of Congress, LC-DIG-det-4a07015.)

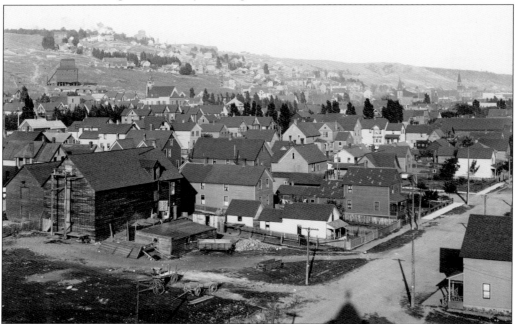

This view looks northeast with Water Street and the shadow of the dome and cross atop St. Joseph's Hospital in the foreground. The Hancock Mine shaft-rockhouse is near the upper left. Multiple Quincy Street steeples are seen in the distance, the tallest being that of St. Patrick's Catholic Church. (Library of Congress, LC-DIG-det-4a07016.)

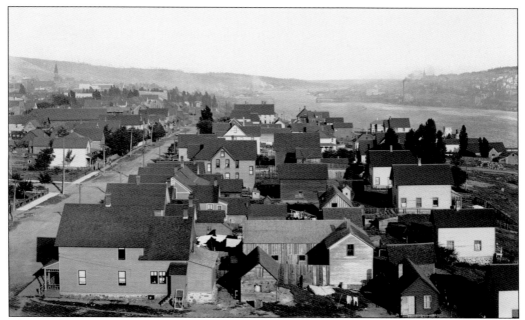

The final image in this sequence shows Water Street on the left and Portage Lake on the right. This photograph appears to have been taken while the bridge was without an operating swing section following the *Northern Wave* collision of April 15, 1905. (Library of Congress, LC-DIG-det-4a07017.)

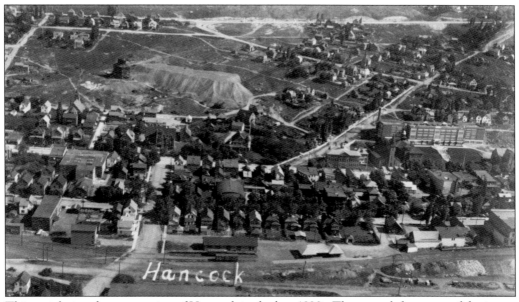

This aerial view shows a portion of Hancock in the late 1920s. The upper-left quarter of the image is dominated by the old Hancock Mine No. 1 site. This area is now fully developed with residences and Finlandia University buildings. In the center foreground are the Duluth, South Shore & Atlantic Railroad's freight (left) and passenger (right) depots. (Joseph Meinardi family.)

Originally constructed as a Works Progress Administration project in the 1930s, this pedestrian walkway extends from the end of the bridge to the East Hancock residential neighborhood. The steps' masonry work was restored, and bollard lighting was installed in 2013. The East Hancock Historic Neighborhood District was added to the National Register of Historic Places on June 23, 1980. (Nancy Sanderson-Keweenaw County Historical Society.)

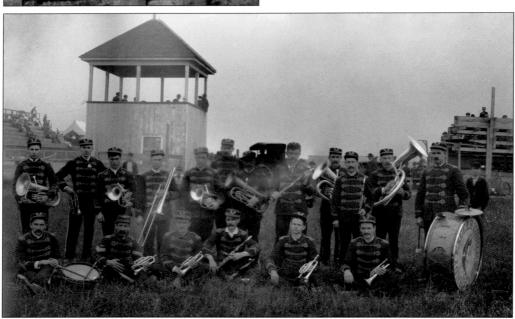

The Quincy Excelsior Band is shown on the grounds of Hancock's Driving Park. The city purchased Driving Park from A.J. Scott in 1905 with the condition that he use the purchase price toward the construction of a first-rate hotel (the Scott Hotel). Driving Park remains a recreation area to this day, hosting baseball, softball, soccer, the Houghton County Fair, and more. (Michigan Technological University Archives and Copper Country Historical Collections.)

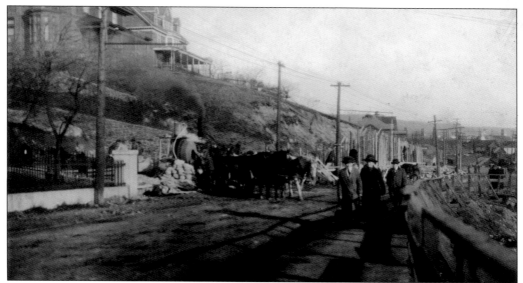

Concrete is being mixed and forms set for the Front Street retaining wall. The wall was completed in November 1912 and remains the gateway to Hancock. (Houghton County Historical Society.)

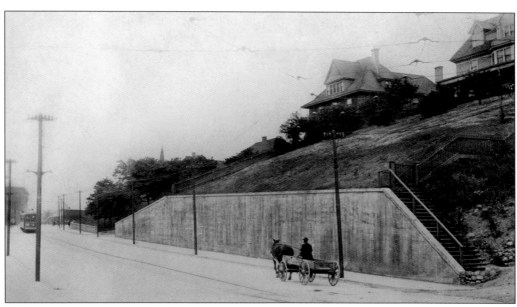

The completed Front Street retaining wall is seen in this early view. The upper-right building, a former residence, became Hancock's Suomalainen Sairaala (also known as Bethany Hospital or Clinic Hospital) in 1917. Catering to Finnish immigrants, the hospital survived about a decade under the direction of Dr. Henry Holm. It later became the Gardens of Italy café, which was destroyed by fire on May 6, 1931. (Houghton County Historical Society.)

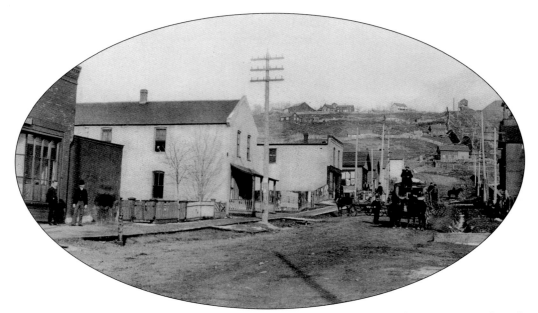

This c. 1880 Reservation Street view looks north toward Quincy Street. The First National Bank of Hancock, organized in 1874, is at the far left. Fourth from left, with three men standing in front, is the office of the *Northwestern Mining Journal*, at the corner of Quincy Street. The original fire hall is at the far right, with the Quincy tramway running behind it. (Michigan Technological University Archives and Copper Country Historical Collections.)

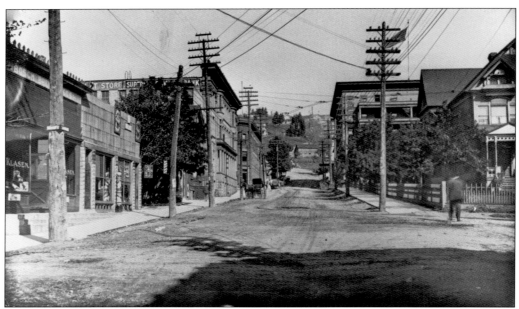

This photograph was taken around 1912 from a similar location to that above. At the far left is Peter Klasen's saloon. The horse and buggy on the left are next to the Wright Block, which contains Superior Savings Bank. The Ruppe house is at the far right, with the Scott Hotel behind it. (Michigan Technological University Archives and Copper Country Historical Collections.)

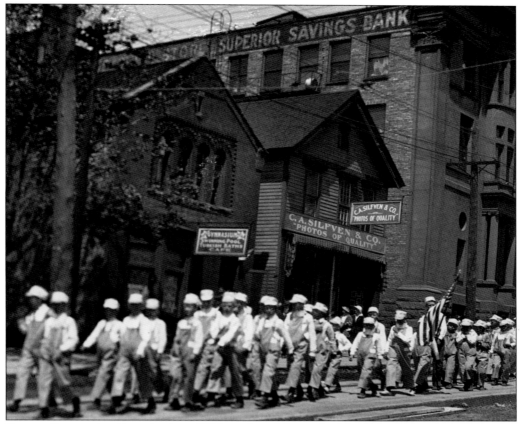

Seen on Reservation Street in about 1920 are, from left to right, North Star (Finnish) Temperance Hall, with a gymnasium, a swimming pool, Turkish baths, and a café; C.A. Silfven's photography studio; and the Wright Block. (Michigan Technological University Archives and Copper Country Historical Collections.)

Taken outside of the First Congregational Church in 1927, this photograph includes John T. Reeder (labeled "5"), a prolific photographer who is responsible for many of the images seen in this book. Other early Hancock and Copper Country photographers include R. Acton, Louis Auer, Frederick C. Haefer, Adolph Isler, Charles A. Kukkonen, J. Pinten, and Carl Albert Silfven. (Michigan Technological University Archives and Copper Country Historical Collections.)

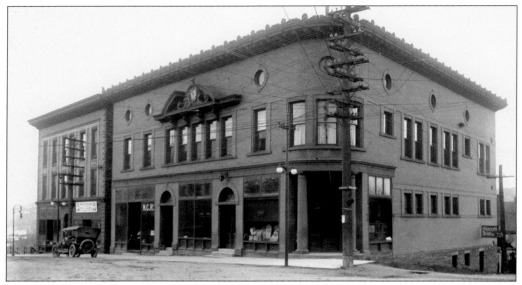

Designed by Hans T. Liebert, the Hancock Elks' Temple stood at the corner of Front and Reservation Streets. The first floor was commercial space, with the main hall located upstairs. Seen here around 1915, the building was destroyed by fire on December 23, 1944. The Exley Building next door (left) was also lost to fire in 1977. (National Park Service, Keweenaw National Historical Park, Myrno Petermann Glass Plate No. 538.)

Nestor Lepisto's grocery and meats store is shown on Franklin Street around 1916. Lepisto was one of many Finnish immigrants to become a Hancock merchant. (Houghton County Historical Society.)

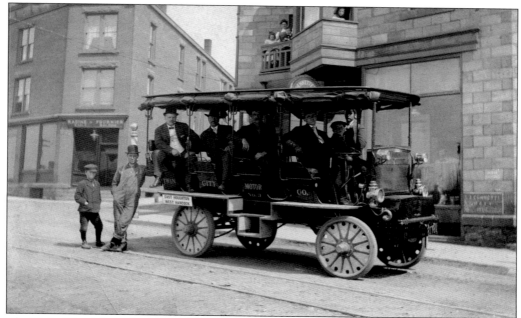

The Twin City Motor Company's car No. 3, a Grabowsky power wagon, is seen in front of the Gennette Block in about 1910. The company was organized by Charles B. Ulrich in 1908 and offered service from East Houghton to West Hancock. Archibald Racine's saloon is on the left, and both buildings seen here still stand today. (Jeff Thiel.)

This oddly shaped, tile-block building was designed by Byron H. Pierce for Sanara Gennette. It opened on the corner of Railroad Avenue (now South Lincoln Drive) and Elevation Street in 1906 and featured a saloon and baths. The Gennette Block survives today, with a similar appearance, as an apartment building. (Houghton County Historical Society.)

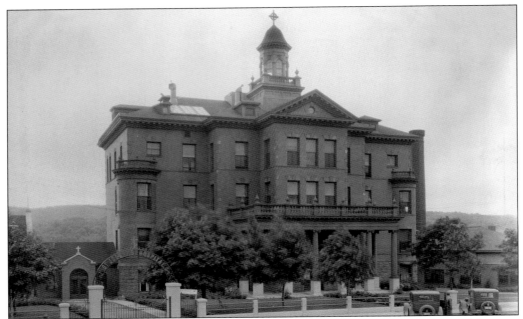

St. Joseph's Hospital, operated by the Sisters of St. Joseph of Carondelet, St. Louis, Missouri, opened on Water Street in 1904. The hospital served as such until 1951, when a larger hospital was constructed nearby on Michigan Street. The entrance to an adjoining chapel, constructed in 1929, is seen in the lower left of this image, taken about 1931. The former hospital and chapel were demolished in 1985. (Portage Health.)

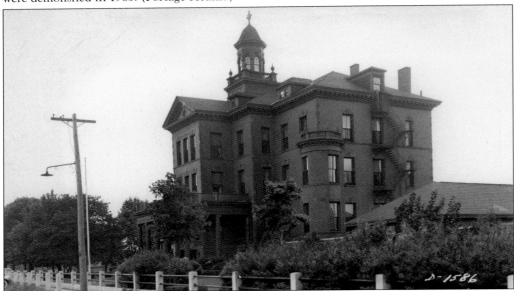

This view of St. Joseph's Hospital is from an old postcard. Author Corbin Eddy wrote, "The building was unique to the area, designed in the style of a Renaissance chateau appropriate to the French roots of the Sisters of St. Joseph. Perched high above the canal, it featured formal entrances, ornate masonry, turrets, and gables. Its interior had paneled ceilings and carefully detailed oak window and door frames." (Author's collection.)

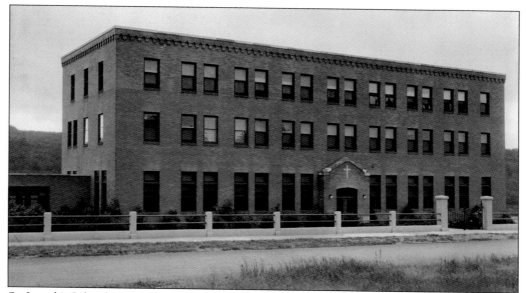

St. Joseph's School of Nursing was organized at the hospital in 1920. The nurses' residence seen here was constructed just west of the hospital in 1929 with funds provided by Hancock-born industrialist John D. Ryan. The building is now owned by Finlandia University. When the new hospital opened in 1951, the former hospital was renamed Ryan Hall and remodeled for the use of the nursing school. (Portage Health.)

GROTTO OF ST. JOSEPH—ST. JOSEPH'S HOSPITAL, HANCOCK, MICHIGAN

This grotto was erected behind St. Joseph's Chapel and surrounded by a serene garden. It was neglected following the closure of the nursing school in the 1970s. In 2013, a group of citizens began restoring the grotto and beautifying the grounds around it. They have christened the area "Carondelet Park" in honor of the sisters who served in Hancock for more than a century. (Corbin Eddy/Eva Vencato.)

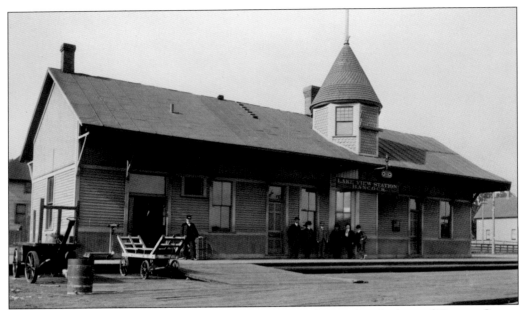

The Mineral Range Railroad's Lake View Station originally stood at the base of Tezcuco Street. The passenger station was moved west and up the hill from the waterfront to what is now Depot Street in the late 1890s after the Duluth, South Shore & Atlantic Railroad acquired Mineral Range. This station, seen around 1907, was replaced with a more modern one in 1916. (Jack Deo-Superior View.)

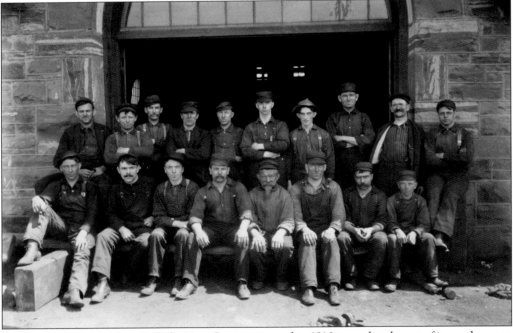

Employees are seen at the new Lake View Station, opened in 1916 immediately east of its predecessor, roughly at the foot of Mesnard Street. (Michigan Technological University Archives and Copper Country Historical Collections.)

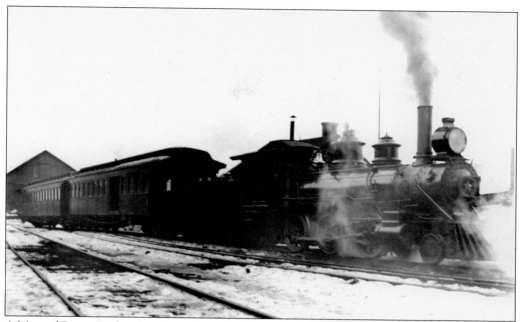

A Mineral Range Railroad engine is shown in Hancock in this undated photograph. Mineral Range began as a narrow-gauge railway and was converted to standard gauge in the 1890s after coming under the control of the Duluth, South Shore & Atlantic Railroad. (Michigan Technological University Archives and Copper Country Historical Collections.)

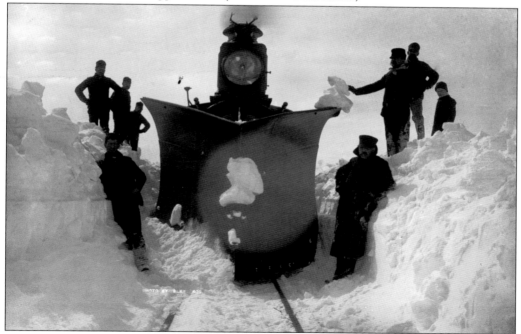

A Hancock & Calumet Railroad snowplow clears the tracks on a typical winter day in the Copper Country. Originally a competitor, Hancock & Calumet was later acquired by Mineral Range. (Michigan Technological University Archives and Copper Country Historical Collections.)

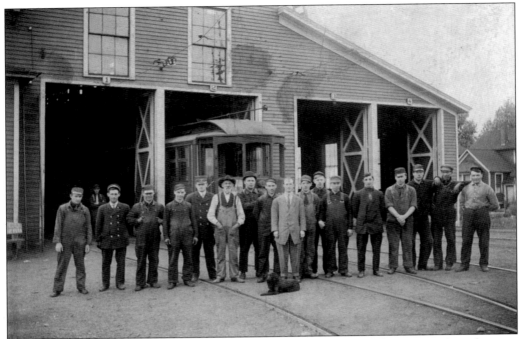

Houghton County Traction Company employees are seen in front of the company's car barn on Ethel Avenue in West Hancock. The streetcar company operated from 1900 to 1932. This car barn is still used today by a sand and gravel company. (Houghton County Historical Society.)

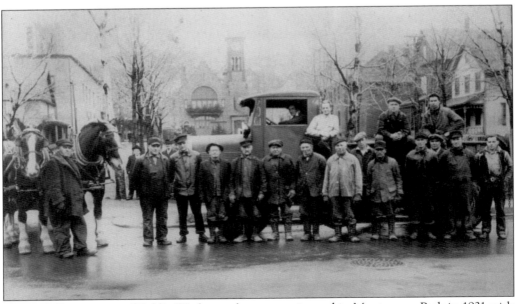

Hancock Department of Public Works employees are pictured in Montezuma Park in 1931 with City Hall in the background. The city employees have done an exceptional job over the years at maintaining and upgrading infrastructure and coping with an average annual snowfall in excess of 210 inches. (City of Hancock.)

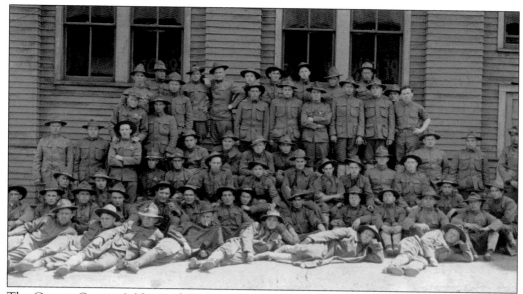

The Copper Country's National Guard Company G is shown in 1916 prior to heading to the Mexican border in the Pancho Villa affair. The company was later called up to become part of the 32nd Division, 125th Regiment, which served with great distinction in France and Germany during World War I. (Houghton County Historical Society.)

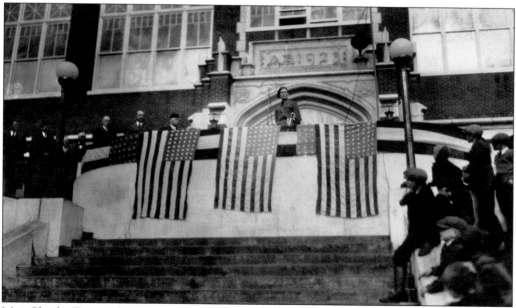

Maj. Charles Francis Sawyer stands in front of the new Hancock High School during an ROTC commissioning ceremony in about 1931. Sawyer served in World War II and the Korean War, attaining the rank of lieutenant colonel. He is buried in Arlington National Cemetery. (Michigan Technological University Archives and Copper Country Historical Collections.)

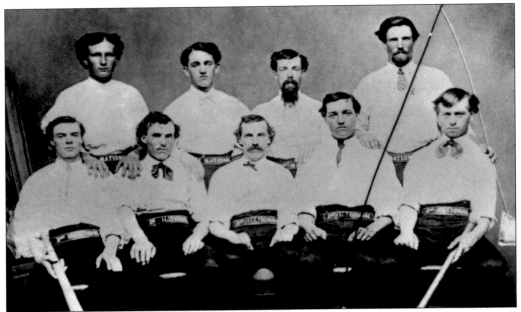

This is the earliest known photograph of a Hancock athletic team, the First National Base Ball Club, taken in about 1870. Pictured from left to right are (first row) James Walls Trembath, Archibald J. Scott, Thomas D. Meads, John T.V. Trembath, and Otto Charles Kunath; (second row) John Bittenbender, Albert A. Brockway, William Harry, and Joseph Johnson. (Michigan Technological University Archives and Copper Country Historical Collections.)

A trio of Scott Hotel employees are pictured here around 1912. Hilma Ryan is at the left, and the other women are believed to be Mary Waali (center) and Annie Harkonen (right). (Ken Linna.)

This women's suffrage party was held at the Reservation Street home of Dr. Peter and Mary Steinback. It appears to be a joyous occasion, likely celebrating Michigan's ratification of the 19th Amendment to the US Constitution in 1919 or the amendment's completed ratification in 1920. (National Park Service, Keweenaw National Historical Park, Margaret Blander and Helmi Warren Family Papers, Album Helmi1, Image No. 084.)

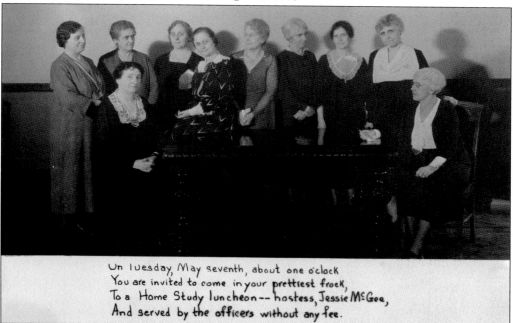

Members of the Hancock Home Study Club received this invitation to their May 7, 1935, meeting. The club's 1934–1935 officers are pictured. Founded in 1883, the women's civic club continues to meet regularly to this day. (Michigan Technological University Archives and Copper Country Historical Collections.)

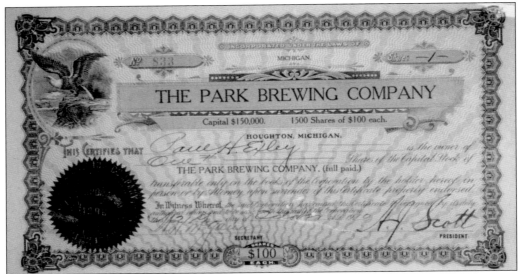

Hancock's Park Brewing Company was incorporated in 1906. This 1910 stock certificate was issued to local blacksmith and wagon maker Paul H. Exley and signed by A.J. Scott and William H. McGann, president and secretary of the company, respectively. The mention of Houghton presumably refers to the county. (Michigan Technological University Archives and Copper Country Historical Collections.)

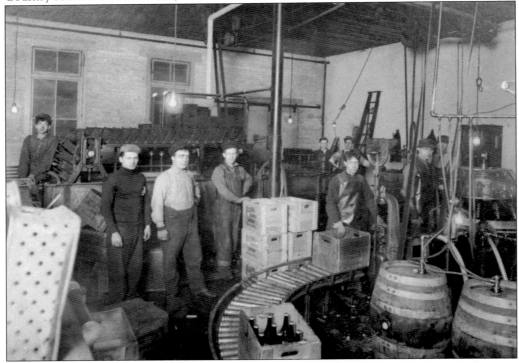

The Park Brewing Company's bottling operation is seen in this c. 1911 interior view. It is not known how much product testing for quality control was done by employees after business hours. (Michigan Technological University Archives and Copper Country Historical Collections.)

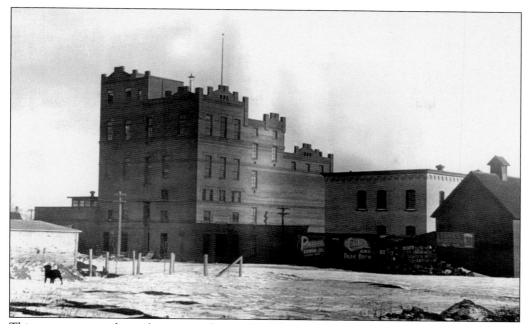

This exterior image shows the magnitude of the Park Brewing Company's facilities, located on Emma Avenue just north of Atlantic Street. Following Park's closure in about 1940, the Haas Brewing Company moved here from Houghton and continued to operate until 1954. (Mike Lahti.)

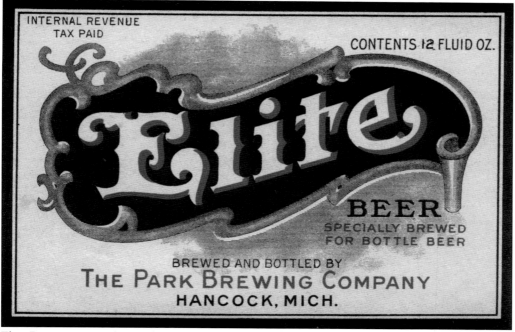

Elite Beer was one of several varieties produced by the Park Brewing Company. Bottles, labels, and other items from the company are sought by collectors today. This label is from approximately 1936. (Author's collection.)

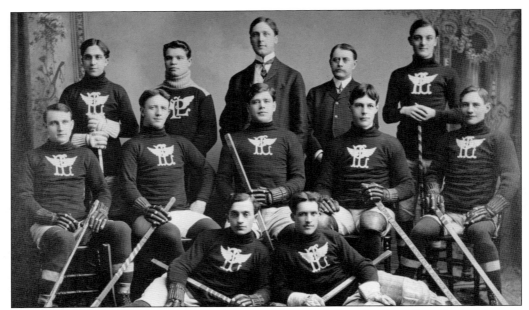

The 1903–1904 Portage Lake hockey club is widely regarded as the first all-professional team. They drubbed the Montreal Wanderers in a two-game series in Houghton to claim the world championship, and four team members are enshrined in the Hockey Hall of Fame. Player Joseph Linder (third row, far right) was a Hancock High School sophomore at the time. (Michigan Technological University Archives and Copper Country Historical Collections.)

Hancock (also known as Hancock Central) High School claimed their second of three consecutive state hockey titles in 1904–1905, led by junior Joseph Linder (third row, second from left). Linder coached the team his senior year after four years of high school play had exhausted his eligibility. An early American star, the Hancock-born Linder was inducted into the US Hockey Hall of Fame in 1975. (Houghton County Historical Society.)

The 1939–1940 Hancock Rangers were local league champions. Their roster included Reino Keranen (second row, second from right) and Alvin "Governor" Laurn (second row, far right). Keranen, a US Army staff sergeant, was killed in France in early 1945. Laurn was lost aboard the USS *Gambier Bay* in the Battle off Samar, the center of the largest naval battle of World War II, on October 25, 1944. Hancock's Robert Grove and Elmer Schaaf were serving on the merchant marine vessel *James Sprunt* when it was torpedoed in the Caribbean Sea on March 10, 1943. Laurn-Grove Park, named for Alvin Laurn and Robert Grove, who both grew up in the neighborhood, contains Hancock's last remaining outdoor municipal ice rink. Mayor Michael A. Simula dedicated the park in 1947 as "a living memorial . . . a small and humble recognition compared to their great and sacrificing service." Keranen, Laurn, Grove, and Schaaf are four of approximately 40 young men from Hancock who gave their lives in World War II. May they never be forgotten. (City of Hancock.)

Suggested Readings

Alexander, Eleanor A. *East Hancock Revisited: History of a Neighborhood Circa 1880–1920.* Hancock, MI: self-published, 1984.

Barkell, Gordon G., ed. *Hancock, Michigan Centennial 1863–1963.* Hancock, MI: Hancock Centennial Committee, 1963.

Burg, Thomas E., ed. *South Shore Steam: Locomotives of the Duluth, South Shore & Atlantic Railway and Mineral Range Railroad.* Merrill, WI: Merrill Publishing Associates, 2011.

Holland, A.H. *1887–8 Hand-Book and Guide to Hancock, Mich.* Marquette, MI: Mining Journal Book and Job Print, 1887.

Johnson, Karen S. and Deborah K. Frontiera. *Picturing the Past: Finlandia University, 1896 to the Present.* Hancock, MI: Finlandia University, 2013.

Lankton, Larry D. and Charles K. Hyde. *Old Reliable: An Illustrated History of the Quincy Mining Company.* Hancock, MI: Quincy Mine Hoist Association, Inc., 1982.

Mahon, Laura and John S. Haeussler, eds. *Hidden Gems and Towering Tales: A Hancock, Michigan Anthology.* Hancock, MI: City of Hancock, 2013.

Maki, Wilbert B. *Reflections of the Hancock Copper Mine.* Hancock, MI: self-published, 1982.

Monette, Clarence J. *Hancock, Michigan Remembered Volume I.* Lake Linden, MI: self-published, 1982.

Monette, Clarence J. *Hancock, Michigan Remembered Volume II: Churches of Hancock.* Lake Linden, MI: self-published, 1985.

Rezek, Rev. Antoine Ivan. *History of the Diocese of Sault Ste. Marie and Marquette Vol. II.* Houghton, MI: Roman Catholic Diocese of Marquette, 1907.

Sanderson, Nancy Ann. *Copper Country Postcards.* Eagle Harbor, MI: Keweenaw County Historical Society, 2005.

Sproule, William J. *Copper Country Streetcars.* Charleston, SC: Arcadia Publishing, 2013.

Taylor, Richard E. *Houghton County: 1870–1920.* Charleston, SC: Arcadia Publishing, 2006.

Local Historical Organizations

Each dedicated to the preservation of history, the following Copper Country organizations served as primary sources of images contained in this book:

Located at 435 Quincy Street in downtown Hancock, Finlandia University's Finnish American Heritage Center opened in 1990. The center is home to the Finnish American Historical Archive, the largest collection of Finnish American materials in the world. Founded in 1932, the archive's mission is to preserve and promote Finnish American culture. For additional information, please contact (906)487-7347 or archives@finlandia.edu.

The Houghton County Historical Society's complex is located on Michigan Highway 26 in Lake Linden. The society, founded in 1866, is the steward of several buildings, exhibits, and collections. Their campus includes the Perl Merrill Research Center, home to a wide variety of documents and images related to the history of Houghton County. For additional information, please contact (906)296-4121 or president@houghtonhistory.org.

With units at Quincy and Calumet and with partner heritage sites throughout the Copper Country, the Keweenaw National Historical Park is highly visible in the region. Its collections at the park archives in Calumet include records of mining companies, other businesses, fraternal organizations, and churches; personal and family papers; and photographs. For additional information, please contact the park archivist at (906)483-3032 or jeremiah_mason@nps.gov.

The Michigan Technological University Archives and Copper Country Historical Collections is a department within the J. Robert Van Pelt and John and Ruanne Opie Library in Houghton. The archives operates primarily as a manuscript repository for regional history materials and holds the most significant collection of manuscript material pertaining to Michigan's historic copper mining district. It is a midsize regional history archives dedicated to preserving the social, cultural, industrial, economic, and educational history of Michigan's Copper Country, which includes Houghton, Keweenaw, Baraga, and Ontonagon Counties along the south shore of Lake Superior. For additional information, please contact (906)487-2505 or copper@mtu.edu.

Discover Thousands of Local History Books Featuring Millions of Vintage Images

Arcadia Publishing, the leading local history publisher in the United States, is committed to making history accessible and meaningful through publishing books that celebrate and preserve the heritage of America's people and places.

Find more books like this at
www.arcadiapublishing.com

Search for your hometown history, your old stomping grounds, and even your favorite sports team.